NO SMALL MATTER

NO S

FELICE C. FRANKEL

Printed in the United States of America

Cataloging-in-Publication Data available from the Library of Congress
Library of Congress Control Number: 2009931380
ISBN 978-0-647-03566-9 (alk. paper)

Contents

NO SMALL MATTER

Introduction

WE UNDERSTAND THE WORLD INTUITIVELY over only a tiny range of sizes—sizes in the middle, between "very large" and "very small." We know how a splinter stings when it slips under our thumbnail, how much a sack of potatoes weighs, how it feels to throw a softball, how difficult it is to pick up a pony. We have never personally dropped a galaxy, or knowingly sat on an individual atom. When things are approximately our size, we understand them through repeated experience. Over time, our accumulated experience settles into intuition. When things are much bigger than we are, or much smaller, we don't *understand* them in the same sense.

This book is about small things. They're *different*—sometimes *really*, and enthrallingly, different. We humans have always been fascinated by "small": the gears and springs of a fine watch, embroidery, a jumping spider—each is a distinct kind of marvel. We think of ourselves as master artisans, and we have a connoisseur's appreciation of delicate work.

But small things are *now* particularly interesting to us. Why? Why *now*? To start, we have new "eyes"—new measuring devices—to see what has always before been invisible; also new tools to sculpt matter at the scale of atoms. We are curious to know: what *are* those things that we cannot see, no matter how hard we squint? We know they are there, but not what they look like. And by the way, what happens if we push *this* atom over *there*?

We humans are incorrigible tinkerers. From childhood on, we have stuck forks into light sockets to see what would happen. Now we have an entirely new set of tiny sockets into which we can stick tiny new forks. Can minuscule sockets still blow big fuses? How small can something *be*, we wonder, and still work? And if we make it even smaller…?

Small things are, of course, sometimes also very valuable. We would like to *exploit* technologies that make the smallest things for our various ends: to fabricate the components of computer chips, to control the behavior of molecules, to manipulate cells. The ability to build very small things has the potential to generate new jobs, goods, and wealth. Capitalism licks its chops in contented, avaricious anticipation.

There is also the matter of "life." "Small" is a door to the microscopic palace we call the cell. We have finally realized that a master craftsman— evolution—has been at work long before us (in fact, long before we existed

as a species), trying out the smallest designs. Among the most sophisticated nanomachines and nanodevices we know are the components of living cells. And the cell itself—a micron-scale object—is complex in ways we do not begin to understand, and will not be able to mimic for many decades. Nature is an almost inexhaustible store of marvelous demonstrations of designs—the system for efficient packing of DNA, the sensors to communicate from outside to inside cells—that we might never have imagined. Nature also bristles with helpful hints about unfamiliar strategies for fabrication.

And, finally, our own evolution has blessed and burdened us with explorer's genes. We simply *must* know what is there, at the smallest scale. We can't help ourselves. We can no more ignore the nanoworld than Hillary could ignore Everest, or Neil Armstrong the moon.

The last few decades have seen the germination of new methods for seeing and manipulating minute things, and the flowering of science based on these methods. We happily anticipate continuing harvests of technologies and their products. But our skills in investigation and fabrication go only so far. What happens when things shrink beyond the range of our intuition and experience? Are small things just like big ones, only smaller? Or are they really *strange?* Despite a difference in size, an elephant shrew is, after all, the physiological first cousin to an elephant, and a seed pearl is not so different from a wrecking ball. But a nanotube and a soda straw are *fundamentally* different, as are the rotary motors that power bacteria and locomotives. One of the fascinations of small things is that they turn out to be so alien, in spite of superficial similarities in shape or function to larger, more familiar relatives. Discovering these differences at the smallest scale is wonderfully engrossing, and using them can change (and has changed) the world.

Two words are often associated with small things: *nano* and *micro*. Each is a unit of size; both are invisibly small. A nanometer is a billionth of a meter, or the size of a small molecule, which is five times the size of the smallest atom, hydrogen. A micron, or micrometer, is much larger—a millionth of a meter, or a little less than the diameter of a red blood cell. Still, it is invisible to the unaided eye. The smallest objects we can see without a microscope—a hair, for example—are about a hundred times larger, or about 100 microns in diameter.

So, "micro" is already invisible: why focus on even smaller things? Why go beyond invisible, to nano? We offer eight reasons.

Information Technology. In the last fifty years, information technology (IT) has completely reshaped our global and local societies. Consumers see, play with, and talk to only a few of the most obvious devices—laptops, cell phones, electronic games, Blackberries—that are based on nanoscale electronics and optics. The innumerable, less evident, devices are everywhere, and largely hidden to most of their human users and creators. The most important of these are the computers (microprocessors) that run just about everything in our modern world: the switches for the telephone and air traffic control networks; battle management systems; global atmospheric surveillance sensors; controllers for power grids, microwave ovens, and steel mills; devices for monitoring patients in hospitals, and for managing payrolls and accounts receivables, financial transfers, and the banking system. Everything—from a cell phone call that gets a good price on a cartload of bananas in Nigeria to the interactive babble and preening of social networking sites—depends on computers.

The smallest parts of transistors (the switches in microprocessors), and the widths of the wires that connect transistors together, are nanometer in scale—sizes far smaller than "invisible." Some parts of transistors are only a few nanometers in size, and the connecting wires are now shrinking past 40 nanometers—less than the length of 100 gold atoms laid end to end, thinner than one thousandth the width of a baby's eyelash. It is almost unbelievable that we have learned not just how to fabricate structures of such delicacy, but how to make them in unimaginable numbers. The resulting computers, and networks of computers, and communications systems that connect computers and computer-containing devices, make up the collective construction we call the Internet. It is the largest, most ambitious, most intricate engineering project our species has ever imagined. We have launched it into the world and are working diligently to help it grow in scale, complexity, and sophistication. But as with our animate children, we have no real idea what it will turn out to be when fully grown, or where it will lead us.

Life, and the Cell. We humans are intensely interested in everything else in our world that is alive, and in life itself. The smallest unit of life is the cell. Higher organisms are assemblies of them, but by far the most numerous of life forms with which we share the earth are single-cell organisms, which range from about 1 to 10 microns in size.

Cells are packed with complex, functional structures that are the products of the astonishing processes described by Darwin—aggregates of molecules selected from countless random variations because of the advantages they brought to the cell that had them. These aggregates replicate and repair

DNA, transcribe DNA into RNA, make proteins and other functional parts of the cell, separate the contents of the cell into two equal parts during division, recognize pathogens, generate energy, sense and react to the environment, construct all the molecules required by the cell, move the cell and its components from place to place, and on and on. To understand life, we must understand the essential parts of the cell, and biological nanostructures are high on the list of those parts we must (but are only beginning to) understand.

Physical Measurement at the Atomic and Molecular Scale. Nano has brought a new capability to basic science: a way to "see" atoms and molecules on surfaces. One of the founding inventions of nanoscience is the set of instruments that enable, for the first time, the visualization of surface structures at the scale of atoms and molecules. These marvelous devices—scanning probe microscopes—operate on principles entirely unlike those of familiar optical microscopes.

The key element in every SPM is its cantilever—a tiny, flexible finger, usually with a tip that has been sharpened to a point a few atoms in radius. The cantilever and tip are the sensing element of the device—the functional equivalent of the lenses that focus and collect light in a microscope. This tip, when placed at a distance from the surface that is about the diameter of an atom, "feels" the proximity of the atoms on that surface as an attraction or repulsion, and it bends in response. Tiny though this movement may be, it can be quantified and used to generate an atomic-scale image of the surface. Scientific revolutions often ride on the backs of new tools, and so it has been with nanotechnology.

The Unique Properties of Small Pieces of Matter. Particles of matter with nanometer-scale dimensions have obvious differences from larger things. For one, a particle that is very small includes only a small numbers of atoms or molecules. Most of science deals with the *average* behaviors of very, very large numbers of molecules. (In the single shot of your afternoon espresso there are a million million million million molecules of water—technically 10^{24}—a number so large that it is literally unimaginable.) In a droplet of water with a radius of 2 nanometers—a droplet about the size of a small protein molecule—there will be about a thousand molecules of water. The statistics on which we so comfortably rely for accurate information about the average behaviors of large numbers of molecules begins to break down with nanoscale samples, and more of the idiosyncrasies of the individual molecules start to peek through. We know that thinking about the behaviors of the populations of cities is one thing; thinking about small groups in those cities is another; thinking about the individuals who live in a city is yet a third. The average income of all the

people in a city, and the average income of a smaller group picked randomly out of its telephone book, and the income of a single, random individual are all different. So it is with molecules. Nanoscale collections are particularly interesting: they are neither "very large" numbers of molecules nor "single" molecules, but are rather at the border between the two.

Nanoscale particles are also "all surface." If a particle is small enough—only a few molecules across—then all of those molecules are close to a surface. Molecules at a surface have different properties from those in an interior: they exist at the heterogeneous interface between two more homogeneous worlds. The oddities and unusual properties of matter at surfaces can often be very useful (for example, when nanoscale particles of platinum are used as catalysts to convert crude oil into gasoline).

Materials. Steel, concrete, polyethylene, glass, silicon, liquid crystals, granite, wood, isotopically enriched uranium, and innumerable other materials are the structural and functional elements we use to build things: the chips for computers, the wings of airplanes, contact lenses, knives, armor penetrators, plastic bottles for fizzy water, engine blocks, and countless others. We understand the atomic structure of these materials, and we also understand their macroscopic forms and properties and functions.

But in between—between atoms and machines—lies a world of nanoscale structures that we understand less well: grain boundaries in metals, the tips of cracks, crystalline regions in polymers, voids, interfaces. Many of these structural elements are critically important in determining function, but we have not been able to examine them in the past. Now we can, or at least some of them. We can also make *new* materials with new properties: quantum dots (brilliant, multicolor beacons for the nanoworld); self-assembled monolayers (skins one molecule thick to cover surfaces); nanosized rods and boxes of incredible delicacy.

Quantum Phenomena. We live in a human-scale world governed by physical laws that we believe we understand: balls fall down, objects cannot pass through one another, a person cannot be in two places at once, coffee and cream mix in the cup. But as structures become small enough to reach nanometer scale, quantum phenomena begin to emerge. For quantum objects (if, in fact, we can speak of an electron or even a molecule as an *object*), the rules are completely and disorientingly different. We have excellent mathematical descriptions of these rules—we call them *quantum mechanics*—but what they say disobeys most of the lessons we humans have so painfully learned by dropping many concrete blocks on many toes, and by trying to walk through many glass doors without opening them.

It's a disorienting situation: a familiar world, whose structures follow understandable rules, emerging from a quantum world of electrons and nuclei—of atoms, molecules, and materials—that follow completely different, often counterintuitive rules. Nano is the range of sizes where this transition—from Alice in Wonderland to concrete blocks and window glass—occurs. How does it happen? How can we understand our reality, when it rests on components that exist in a different reality? We know the answer, mathematically; but "knowing" is not "understanding," and "calculation" is not "intuition." Nanoscience may help us understand how "quantum" blurs into "ordinary." And the study of behavior at the quantum level may also offer opportunities for new technologies—technologies so radically outside our experience that we may not even recognize them when they first appear.

Medicine. Since each of us is a nation of cells, and our cells are cities of nanostructures, it seems plausible that nanoscience and nanostructures should be useful in medicine—in illuminating the operating instructions of the cell, in selecting specific cells for destruction or protection, in on-time, precise delivery of drugs to tissues. So far, nanoscience has not produced a bonanza of new medical capabilities, but there are promising beginnings: magnetic colloids that improve the ability of magnetic resonance imaging to detect tumors; drugs dispersed as nanoparticles to improve their availability in the body.

The match in size between the nanostructures in cells and the tools of nanoscience seems so opportune that enthusiasm for the potential of "nanomedicine" only grows with time. We believe, optimistically, that it's just a matter of "more": more time, more money, more luck, and the application of more intelligence. Of course, we believe, optimistically, that *all* new technologies have unlimited promise. We'll see.

Energy, Water, and the Environment. Nanostructures are everywhere in the technologies used to produce and conserve energy. All liquid fuels (gasoline, diesel, jet fuel) start with crude oil—often black semisolids that would be useless in a gas tank. We rely on reactive metal nanostructures (catalysts) to convert them into conveniently pumpable, easily burnable liquids. Fuel cells could not work without nanoscale catalyst particles and nanoporous membranes. Membranes are also essential to the production of potable water from sea water by reverse osmosis.

Nanostructures are a ubiquitous part of the earth's natural climate control. The spray of seawater at the beach breaks up into droplets; when the water evaporates, nanoscale particles of salt remain. These in turn are im-

portant in forming clouds, which influence the heat balance of the planet. Dust, of course, has many sources: wind blowing over dry soil; fires; volcanoes; and others. They all contribute. Nanoscience offers the possibility that understanding these sorts of natural processes might, at best, lead to new skills useful in controlling our environment (we hope by design, and to our benefit) and, at worst, help us comprehend what went wrong.

The border between *nano* and *micro* is the border between the new and the old in the science of small things. Nanoscale structures—objects made of small numbers of atoms and molecules—are one of the greenest pastures in modern science. In our enthusiasm for the new, however, we should not forget that we have grown fat on the old. Nano is sexy, but micro still pays many of the bills. Most of the technologies that have changed the world in the last decades—especially in electronics and photonics (technologies that manipulate information as puffs of electrons or blinks of light)—were developed using micron-scale structures; and for decades to come, micro will be an essential part of the swarms of devices that populate our world.

In venturing from macro to micro to nano, we must watch for unintended consequences. As with all exploration, and all new technologies, there is the possibility of nasty mistakes and unanticipated dangers. We realize that nanostructures have different properties from macrostructures; we know that our intuition is not a perfect guide to their peculiarities. Perhaps some of these properties pose a hazard to those who explore the nanoworld, and even to innocent bystanders. In the cottage industry that has grown up to divine the perils in nanotechnology, a soupçon of apocalypse adds spice to what may be a fairly ordinary scientific soup. But there *are* always unforeseen risks, as well as unforeseen benefits, with any new activity. It is prudent to try to anticipate both. Nothing particularly worrisome has emerged from nanoscience so far, but as more new technologies emerge, we should examine them carefully, with caution in mind.

So: nanoscience is an alluring new starting point for our civilization as it explores the world in which we live; nanotechnology has already become an essential part of the nervous system of a global society that depends on information to keep its parts working cooperatively (and will depend on it even more in the future). For whom, then, have we—the authors—constructed this account of the nanoworld? This book is intended for general readers who are interested in the implications and applications of science. We are ourselves

in love with the subject of nanoscience, in part because of its range—from the intellectual disequilibria of the quantum world, through the evolving saga of life and the cell, to the technologies of information and energy and medicine. We would be delighted to share our enthusiasm with those who read the science pages of a newspaper; with investigators who enjoy science outside their specialty; with high school students and teachers curious about cool stuff; and with just about anyone fascinated with how the world works.

We have used both images and prose to give a sense of the many things that are too small for the eye to see. Images of the invisible world pose a particular problem because we usually cannot generate them with photography. Some of the images we show may *look* like photographs, but they were not produced using light for illumination. They represent the mating of new scientific instruments that can examine small things—scanning probe microscopes, electron microscopes—with computers and computer graphics. A light microscope is simply a magnifying lens that shows what our eye could see if it had the resolution. An electron microscope does not see light at all, but rather electrons (our own eyes are entirely blind to electrons). And an atomic force microscope (a particular kind of scanning probe microscope) produces images that resemble photographs but does not "see" in any sense. Rather, it "feels" the surface and feeds data back to a computer, which cleverly creates maps and converts them into visible images that *look* like photographs.

Images of the very unfamiliar phenomena common in nanoscience—especially quantum behavior—are even more problematic to produce, since these phenomena often cannot be understood fully except through mathematics. Fortunately, an image need not be a photograph of the thing itself to be useful. Just as a hand, a candle, and a wall can create a shadow that gives some sense of a rabbit's shape, the images we show give some idea of the shape of molecules and their arrangement into materials and cells. We also freely use analogies and metaphors—both in images and in words—based on familiar objects; they help almost everyone understand new ideas. We rely on them shamelessly—although we know they are not exact—to try to illuminate unexpected properties of nanosystems. When they are simply incapable of explaining precisely what is going on—as is often the problem in discussing quantum behaviors—analogies and metaphors are still much better than nothing. They give *some* sense of the origins of the unexpected properties of small things, and, failing even in that, they let us express our amazement (and sometimes incomprehension) more clearly than just blurting out "Sorry, we can't explain it, and actually we don't entirely get it ourselves!"

The difference between analogy and reality is usually obvious in this book. We also make an effort to distinguish between various types of images—which "photographs" involve light and "seeing" in the conventional sense, and which images represent the ruminations of a computer trying to summarize science for a species equipped with a specialized set of sensory organs called "eyes." Still, the distinctions may not, after all, be so important. The point is to get a sense for the shape of the thing, not to fret about the details of how we perceive it. In any event, what we see, even with light, is an artifact of our evolution: birds and bees perceive colors that human eyes never will.

And at the end, what can we say about nano? First, that it is *not* at the end, it is at the beginning. Second, it is—as is every large-scale development in science—unique in the way it is unfolding. Quantum mechanics was a single, radically new idea, which exploded over a very short time in the world of physics; the reverberation of this explosion has kept much of science going for a century. Genomics was a toolbox—containing the implements needed to read the information in the genome and rebuild it to order—whose applications have transformed cell biology and our understanding of life. Chemistry developed by taking many smaller steps—catalytic production of fuels and materials and drugs, development of instruments to characterize the structures of the most complex molecules, invention of sophisticated methods of synthesis, construction of a theory to understand the inevitabilities of large numbers of molecules—that have moved society in the directions of comfort and health. Astronomy has relied on new telescopes to see to the beginning of time as we know it. Materials science was created by the government to solve problems in complex machines such as airplanes.

We will not know the ultimate impact of nanoscience and nanotechnology for many years. We *do* know that it is following its own path. Its creators have been the most variegated that a discipline (if it can be called a discipline) has seen: engineers at NEC and Intel, DARPA and Google, building computers and the Internet; physicists providing tools for measurement and interpreting quantum behaviors; chemists and materials scientists synthesizing and catalyzing and fabricating; biologists phrasing the problems posed by "life." Nano has started as a village and a *suq*, with much buying and selling. It may turn out to be the integration of parts of many fields, rather than an entirely new concept. No matter. It is transforming the way we think of our world; it is changing the way science and engineering work together, and rewiring the sociology of technology; it is brokering the movement of knowledge among communities that barely knew of one another's existence.

Also, it's already very, very cool, and very useful.

SMALL

Small is different. Very small is *very* different.

Intuition and experience work with billiard balls and babies. We understand them, we think. Only mathematics works with electrons and atoms; they defy everyday intuition. And yet . . . balls and babies are made of electrons and atoms. How does the commonplace emerge from the unimaginable?

When things are large, they are what they are. When they are small, it's a different game: they are what our measurements make them. At the marches—the regions too complicated for mathematics and too unfamiliar for intuition—strange creatures (with stranger behaviors) emerge . . . and our "experience" turns out to be a Classic Comic version of reality (whatever reality might be).

Santa Maria

1

WHY SAIL OFF THE EDGE OF THE EARTH? Why risk the terrible storms, and the more terrible sea monsters? Why did he choose to go?

For the usual reasons: the enticing prospect of wealth, the even more enticing prospect of fame; for curiosity and the thrill of gambling and one-upmanship. From restlessness and ruthlessness and boredom and a craving for admiration. Because he thought that he might, possibly, get away with it one more time. Columbus set off westward from Spain, aiming for the Indies. It was the wrong direction, but exploration was the right idea, and he found something more valuable than silk: an unclaimed continent!

Nanoscience may seem tame by comparison with exploration of uncharted oceans. It is not. True, an error does not make you snack-food for a sea monster. But what you learn! That the comfortable reality we know—the world where a book on the table is solidly on the table, and doors keep children safe inside—emerges from a *most* uncomfortable, deeper reality where things can be many places at once, and doors provide almost no barrier. We can probably never understand this shadowy, disorienting landscape intuitively, but mathematics guides us through it well.

And what do we discover? That electrons skittering through wires, and collecting in pools, change our society more than spices or silk. That life—the rose in the garden, the aphid on the rose, the microbes in the aphid's gut—is so astonishing that one forgets to breathe. That we just skim the surface of reality; we don't live there.

Columbus's first voyage found what is now called the Bahamas; only on the fourth, after many ricochets, did he accidentally hit Central America. He had no real idea of what he had found, or that others had been there before him. He could not foresee that the colonists he left behind would die or mutiny. But no matter. Columbus was in roughly the right place at roughly the right time. With nano, it is still unclear what is archipelago and what is continent, if, indeed, there is one. No matter: *small* is the right idea for our world and time.

The science of small things is spinning the web—not of silk, but of information—that has made silk roads obsolete. It helps us understand what it means to say that a silkworm is *alive*. It will help to generate the energy and water (and who knows what else?) whose value so far exceeds that of silk and diamonds.

SEPTENTRIO.

Dennemarck

Schwe-
den

Engeland

OCCIDENS.

Franckreich

Saxen

Hispanien

Deudschland

Lothringen

Behemen

Reussen

Meiland

Polen

EVROPA

Vngern

Moschaw

Welschland

Türcken

Griechen-
land

Roma 382.

ARMENIA

MEDEN

Ninive 171.

Ragts 349.

MESOPO
TAMIA

PER-
SIA

INDIA

SIRIA

ASIA

Haran 110.

CHALDEA

Persepolis

Antiochia 70.

Babylon 170.

Susa 230.

Damascus 40.

Vr 156.

ARABIA

JERVSALEM

Saba 312.

Das Rott Meer.

das groß Mittelme-
er der Welt.

Alexandria 72.

Egypten

ORIENS.

Cyrene 284.

LYBIA

Meroe 24.

Morenland

AFRICA

AMERICA
Die Newe
Welt.

Köngreich
Melinde.

CAPVT BO-
NAESPEI.

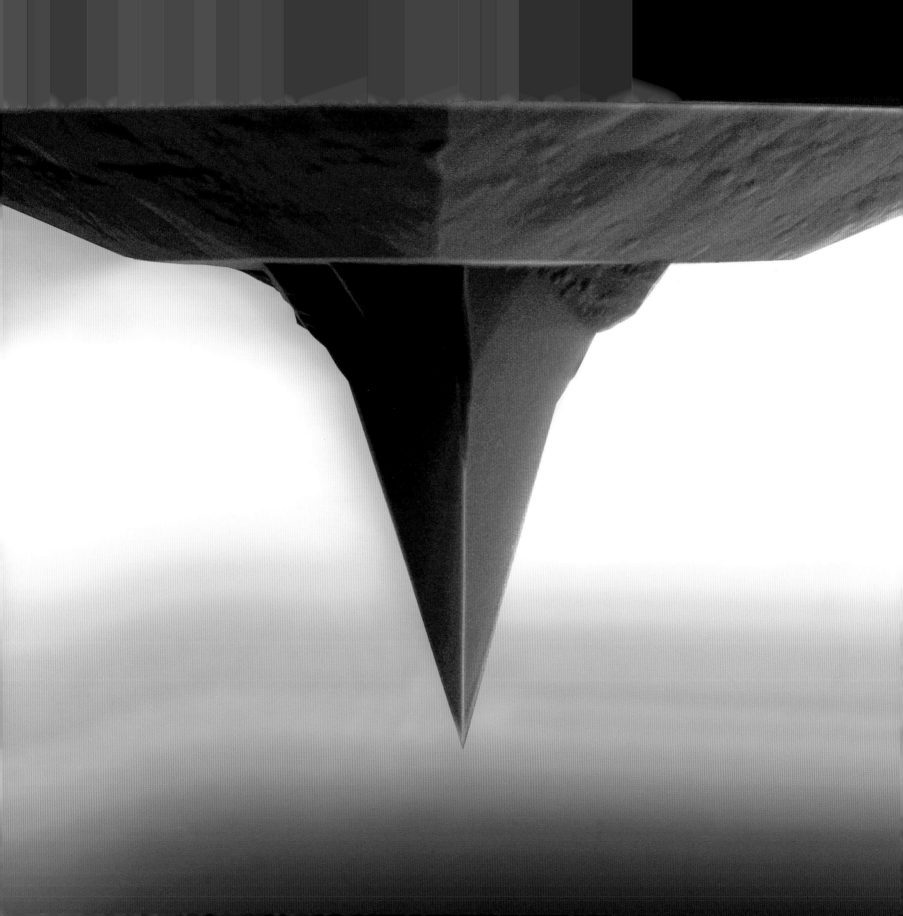

Feeling Is Seeing

WITHOUT A MAGNIFIER, we cannot see objects smaller than a hair. Optical microscopes get us further, but diffraction—the blurring of shadows at sharp edges—kicks in at a few hundred nanometers, and again images blur. We use X-rays and electrons to photograph even nanoscale objects, but we can no longer claim to *see* them: we are semi-blind to the truly miniscule. So: how to navigate the nanoworld?

One approach is the strategy our worm ancestors used—to *feel* rather than to *see*. They lived in mud, where eyes were useless; their skin described their world to them. Feeling is a durable strategy for sensing where there is no light, since it has survived evolution. Cats and catfish use whiskers; cockroaches use antennae.

The atomic force microscope (or AFM)—a finger that brushes surfaces with such delicacy that it can feel individual atoms—was a cornerstone of the foundation of nanoscience. With it, we could *feel* the shapes of molecules! An ecstasy for chemists, whose profession was molecules, but who had never actually seen one.

Of course, the size of a finger limits what it can do: imagine threading a needle while wearing ski gloves. To feel atoms, the tip of the finger must be about the same size as they are. This fingertip looks like a mountain upside down, but it is a shard of silicon sharpened to a point only a few atoms across. To take this photograph, a beam of electrons illuminated the tip.

To draw more complicated pictures by feeling, it is sometimes useful to have many fingers. The child's toy on the following page uses a plate through which many pins slip to replicate the shape of an object pushing up from below. Using many AFM tips at once also works, at a much smaller scale.

Quantum Cascades

3

THE WORD "quantum" has a nice sound. It escaped from "quantum mechanics" to become a kind of pet in English. It affectionately attaches itself to unfamiliar nouns—quantum leap, quantum advance—without too much awkwardness. It associates pleasingly with the mysteries of physics. But what does quantum mean? Simply that something occurs only in packages—quanta—having a specific size.

In an ordinary brook, water flows downhill continuously. In this photograph, water flows down the steps of a cascade, with drops in height that are quantized—about a foot for each step. It seems ordinary enough. What startled physicists was to find such steps occurring spontaneously and unexpectedly in nature. Sprinkle salt in the ghostly blue flame of a gas stove, and the flame flares yellow. Look at this yellow light using the right kind of instrument, and you see only a single color: not a mixture of butter and saffron, but exactly one frequency of yellow. Why?

In the early 1900s, no one knew. The astonishing answer was that electrons could not change their energies continuously (like water flowing in a brook), but could have only specific, fixed energies (like water descending this cascade). The difference in energy as the electrons fell from one level to another thus had a specific value (like the difference between the height of water in two levels of the cascade), and this value determined the color of the light they emitted. The discovery that electrons in matter could only have specific energies led to quantum mechanics, turned science on its ear, and ultimately rewrote our understanding of reality.

To appreciate how unexpected quantization was, consider love—something we consider very different from physics. We like to think that love comes in many kinds. "I love you" (because you are my child), "I love you" (because you've just given me a buttered bagel), "I love you" (because in one glance, you completely fried my brains). All are different. But suppose there was only one kind of love, and it came in well-defined packages—quanta of love? Suppose that all the different kinds of love we perceive were just more or fewer packages, or packages of a particular type? We would be astonished, and profoundly disbelieving. Also horrified—as was physics, when quantum mechanics bloomed.

But if it explained the different qualities of love? Even if the story never felt right, we might have to live with the fact that it explained how love works.

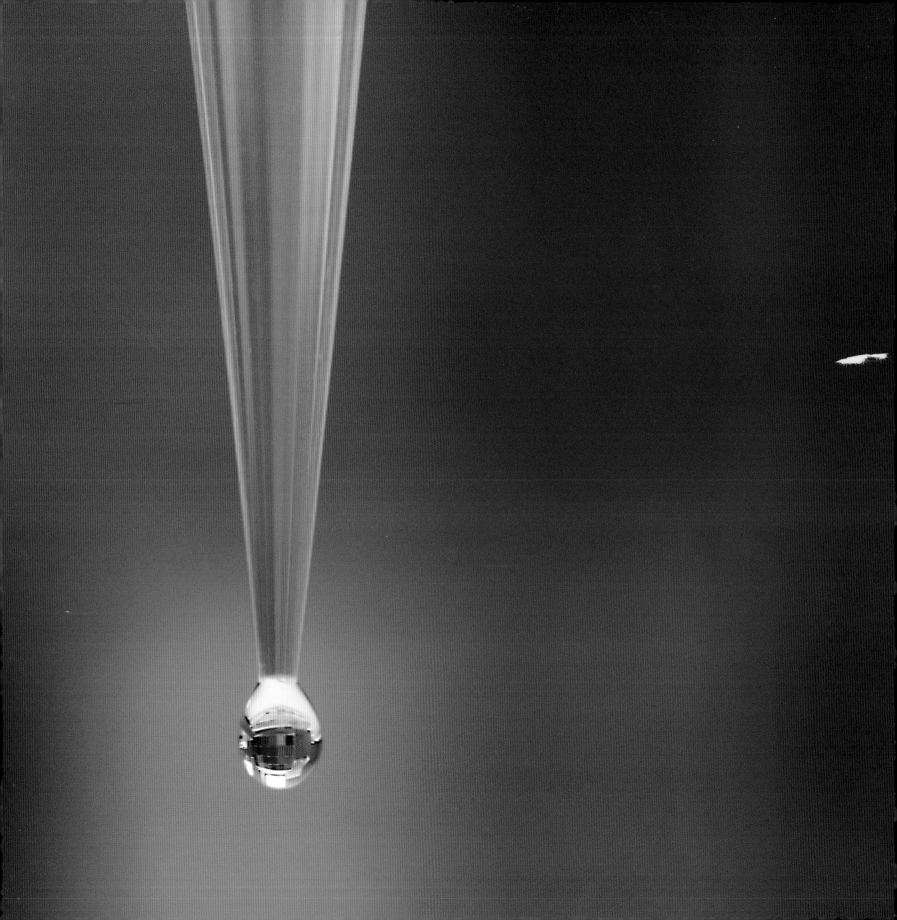

Water

THE OCEANS, AND THE AIR WE BREATHE, are so *obvious* that we are oblivious to them. But obvious can still be essential. We can't exist without obvious molecules: water, carbon dioxide, oxygen, nitrogen. Gold we can do without, but not these. (And, of course, we need sunlight to make it all run, and gravitation to hold everything in place.)

Water is small—just two atoms of hydrogen and one of oxygen: H-O-H or H_2O. How different from other molecules can it be? Well, our children have four limbs, a head, and aggression. How different can *they* be? The answer to both: *very*. To a chemist, water is the little kid with all the talent. It's small, and its two "arms" (the O-H bonds) let it form gangs. It's picky about its friends: water and oil don't mix; neither do water and air. Water molecules much prefer to be insiders, rather than straggle on the edge of the group. Water minimizes its surface whenever possible.

Why doesn't a small drop of water clinging to the end of a pipette, or a faucet, fall? A toothbrush would. Most things fall down, but not a small drop of water. Why not? Think of it from the point of view of the water molecules. For the drop to fall, it must stretch down. But stretching creates more surface, and so forces more of the water molecules to be at the surface. For water, not a comfortable thing to do.

The tendency of water to reduce its surface area is not a minor idiosyncrasy; it is a big thing. It makes soap bubbles and cell membranes what they are, and forces us to shake salad dressing vigorously before using it. It also causes proteins to fold into the correct shape, enables molecular recognition, and is essential to the existence of life.

Might a different molecule—a child with oddities different from those of water— allow a different kind of life? Could life use ammonia, or carbon dioxide, or methane instead? We don't know. As we explore the weird collection of moons scattered around our neighboring planets, and planets circling other suns, we may find stranger things than we can imagine. If we meet a new life form on a distant planet, and it smells like Windex or bitter almonds, we should be wary! And also curious.

Single Molecules

SINCE ATOMS AND MOLECULES make up all of physical reality—everything we can touch, taste, see, and feel—it's a little unnerving that we have never actually *seen* one. High school chemistry goes on about atoms and molecules as if they were as ordinary as mosquitoes. In fact, they are *more* ordinary (or at least more numerous), since each mosquito is made up of billions and billions of molecules. Don't misunderstand: we *know* there are atoms, and molecules, and molecules as collections-of-atoms; but a molecule and I have never sat down across a table and looked at one another.

There are, of course, reasons why I cannot see a molecule. First, it is not a solid object that can be seen in the usual sense: it is almost entirely open space, with a few tiny nuclei and a gossamer haze of electrons. Second, I cannot literally see (even with a microscope) anything smaller than the wavelength of light. The shortest wavelength we can see—about 400 nanometers—makes the color violet. The length of a molecule is about 2 nanometers. Much too small. It would be as difficult for our unaided eyes to see a molecule as it would be to see a Great Dane standing on the moon.

So, it's a comfort to have a new way of seeing—if not a molecule in its atomic splendor, at least where one is. Here we "see" molecules—albeit large molecules—using an atomic force microscope. Not perfect, perhaps—we still do not see individual atoms in this image—but certainly better than nothing. These structures are polymers—threadlike molecules perhaps 500 times longer than the molecules of sugar you add to your morning coffee, or the molecules of caffeine that give it its kick. The skins of atoms that make up their surfaces stick to one another in ways that cause one half of the polymer molecule to coil itself into a ball (which appears in this image as a peak), while the other half splays itself across the surface. What we see are the resulting "ball-and-tail" structures: molecular-scale tadpoles.

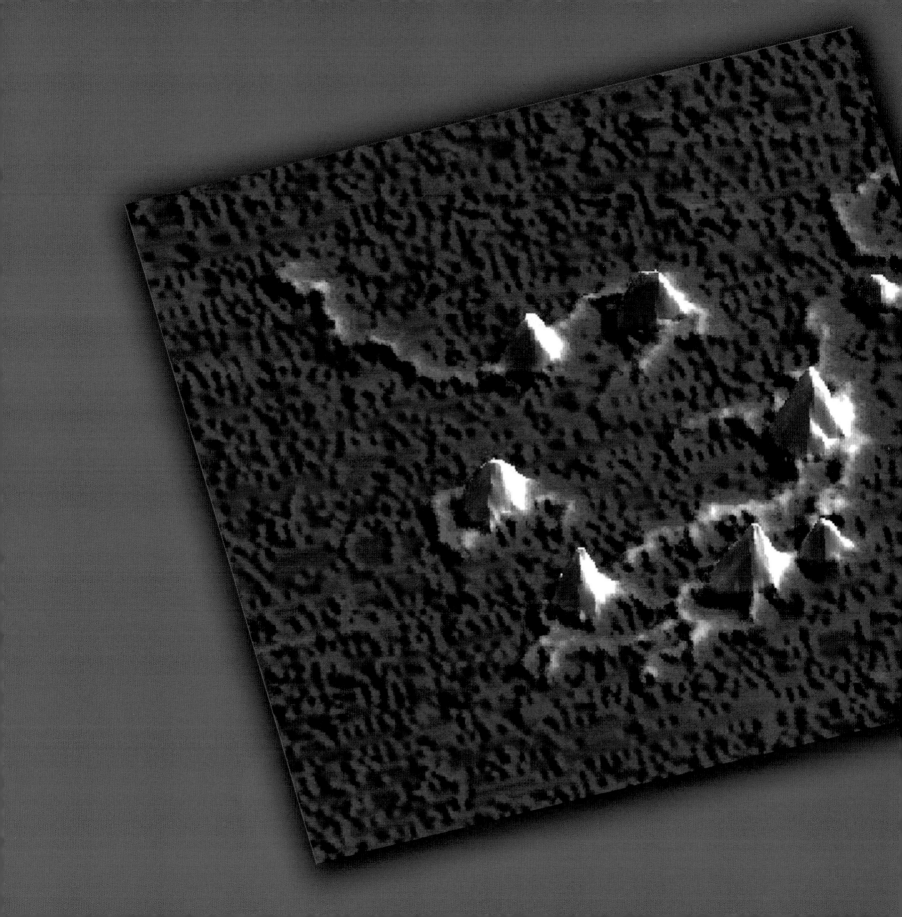

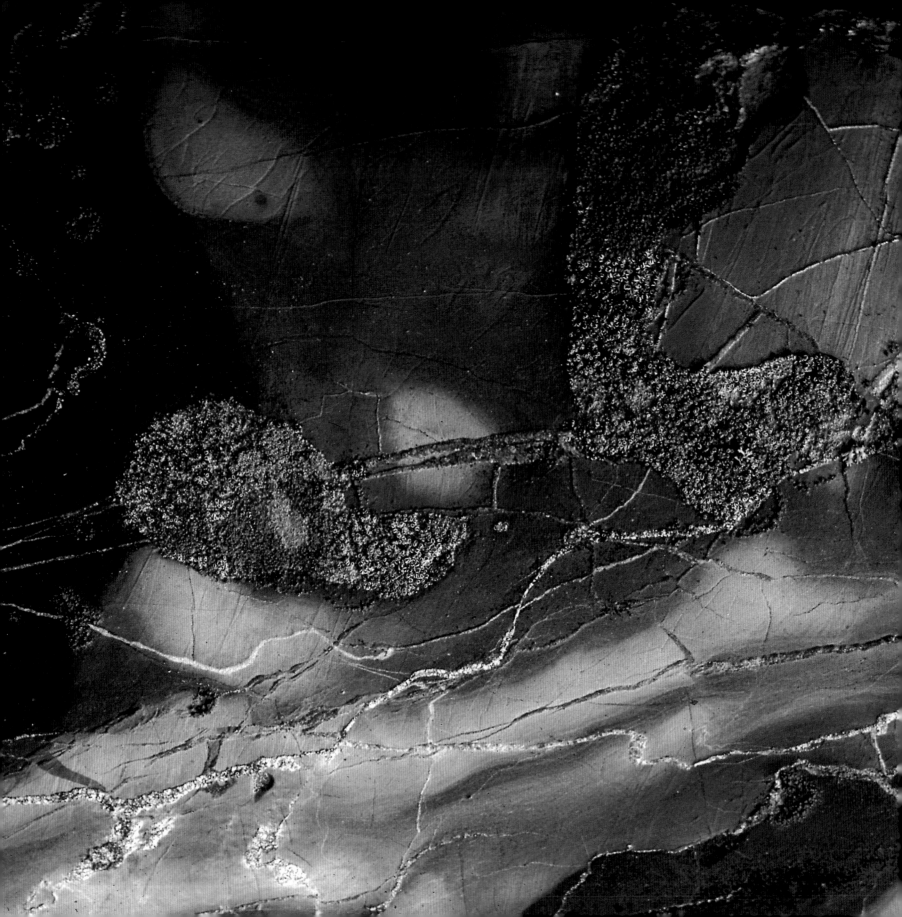

Cracks

6

THESE LICHENS—COLONIES of several symbiotic microorganisms—make their living digesting the bones our planet formed in its infancy. They have a spare life, very slowly extracting carbon dioxide and water from the atmosphere, and dissolving rocks to get the traces of other elements they need to reproduce. As they slowly gnaw away at the stone, they crack it, sometimes aided by the forces of freezing and expansion of water. From the vantagepoint of lichens, this wintertime destruction is a good thing—more rock fragments to chew on.

Lichens do not spend much time thinking about cracking or fracture. Nor do we, unless something valuable breaks. But fracture—whether the result of lichens dissolving granite or eyeglasses dropping on the bathroom floor—requires a crack; and thinking about how matter *cracks* leads directly to thinking about its atomic-scale granularity.

Consider a crack in the lip of that last lovely wineglass your mother left you. It can be large enough to see at one end, and disappear in a ghostly reflection—visible only when you hold it at certain angles to the light—at the other. At the visible end, what you see is the separation (on the scale of hundreds of nanometers) of the two opposed surfaces that the crack created. At the disappearing end, the cracks melts into the continuous solid, and there is no separation. What happens in between?

In fact, for most materials, we do not have a very clear idea of the nanoscale structure at the tip of a crack. When the separation between the surfaces becomes only a few atoms wide, familiar chemistry starts to fail. A crack smaller than an atom makes no sense, but how matter progresses from two distinct pieces to one is not obvious at the atomic scale.

Nanotubes

CARBON COMES IN MANY FORMS. One is diamond—hard, cold, colorless, electrically insulating. Another is graphite—soft, slippery, black, electrically conducting. The difference between them is their atomic connectivity. Diamond is a three-dimensional wonder—every carbon atom welded rigidly to four others in endless ranks of repeating tetrahedra. Graphite is like two-dimensional sheets of chicken wire a single carbon atom thick. The three-dimensional strength of diamond is condensed into the two-dimensional strength of graphite. In its plane, a sheet of graphite is probably stronger than diamond, but graphite has no strength at all in the third dimension: one sheet almost does not know that the adjacent one exists. So there you have it: the same atom, different geometries, wildly different properties.

Take a sheet of graphite, roll it up into a tube or a jelly roll, and you have a nanotube—a hollow, electrically conducting cylinder of graphite. To make the geometry clear, a computer generated this image, but the real tube would be a few nanometers across. The center of the tube is hollow: atoms can fit inside.

Nanotubes have properties that leave builders—of bridges, of information processors—dizzy with anticipation: they have strength, rigidity, and electrical conductivity. The last of these is the first to be applied. Electrons slither along the carbon sheets of nanotubes more smoothly than a silk scarf slips through a silver ring. This extraordinary electrical conductivity might be useful for the batteries needed to store solar energy when the sun goes down, or for very small wires to talk to living cells electrically.

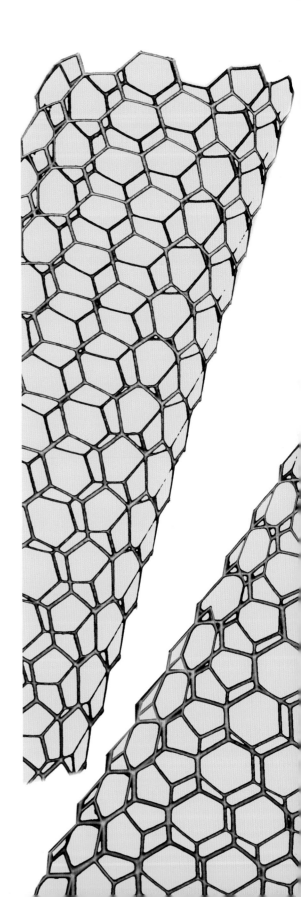

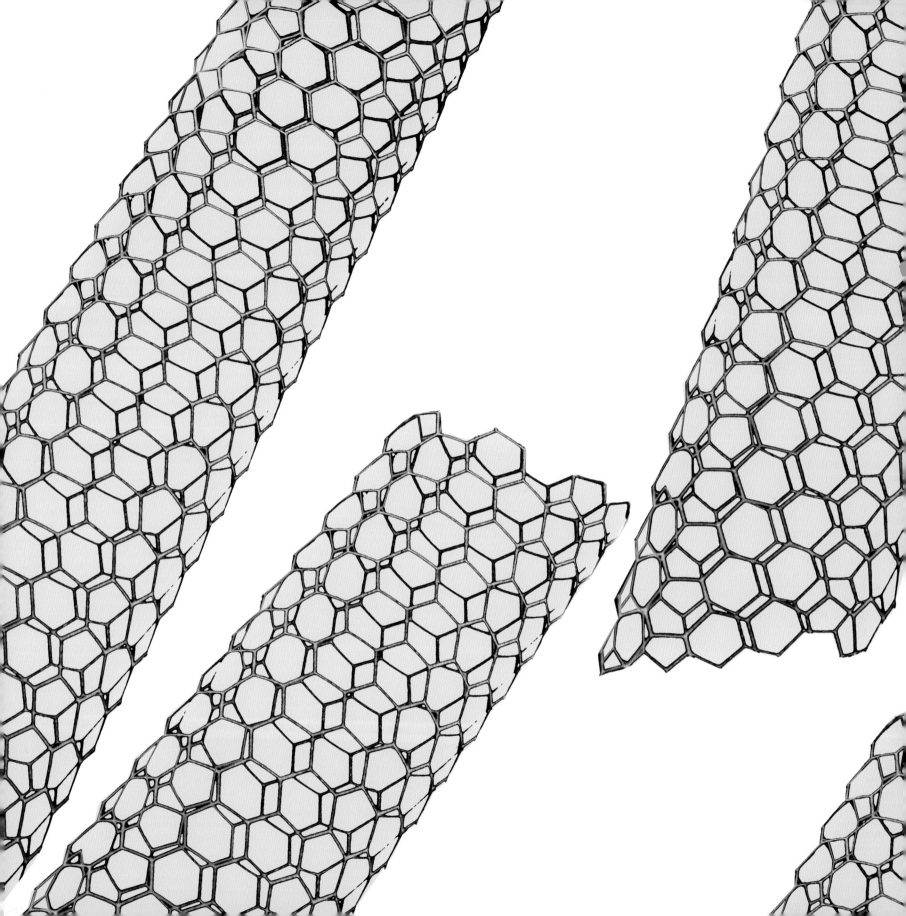

What we call "real" is, and then again it isn't.

You—a large object—can be "here" or "there" but not both places at once. A bell, and the sound made by the bell when struck, are different. But our resolute confidence in the ordinariness of experience—in the behavior of things we touch and see—emerges from the extraordinary reality of much smaller things, which are doing something else entirely, and following different rules.

We can use mathematics to rationalize the *pas de deux* of one electron and one proton in exquisite detail. Many electrons and many nuclei we can guess well enough by analogy. But after the mathematics has done its job, we still don't *understand*. Viewed with one eye, an electron resembles a bell; viewed with the other, it resembles the sound of a struck bell.

Vibrating Viola String

WHAT DO WE NAME SOMETHING when we don't understand what it is that we are naming?

"Vibrating string" is not simply a "string": a string is an object, a length of cotton or polymer or cat gut. And "vibrating" describes regular back-and-forth motion in anything, from bobbleheads on the dashboard to the thorax of a bumblebee in flight. A vibrating string is a composite of two ideas: "string," an object; and "vibrating," a kind of motion. We have no single word for it, but we understand through experience exactly what it is.

"Electron" is the opposite: we use a single word, but have no intuition for what an electron really is. It seems to be something different depending on how we look. An electron moves like a wave. We understand waves: waves in fields of dry grass in the wind; waves of warm and cool air on a summer evening; waves of perfume as the women pass at the concert. An electron hits like a ping-pong ball (albeit a very small one). We understand balls. But an electron is not just a vibrating ball—it is something else. Sometimes it acts like a wave, sometimes like a ball. Intuition suggests that waves and balls should be different. But intuition is wrong: an electron is *both*.

And if we accept the idea that something can be simultaneously wave and object—if we abandon the notion that our experience with big things should extend, unchanged, to small things, and let mathematics be our counter-intuitive guide—we predict the right outcomes. Still, reality is intensely annoying: our familiar world—the grass, ping-pong balls, the air—is made of molecules, and molecules are made of atoms, and atoms are made of electrons and nuclei. But ping-pong balls behave one way, while electrons and their subatomic friends behave another. How can that be? *Why* should that be?

Physicists like to give pet names to wholly phantasmagorical things: black holes, dark matter, electrons, quarks, neutrons. Pet names for strange pets. Whatever we name them, the smallest bricks of which our substantial world is made have properties that don't sit easily with our experience. That's the way the world *is*; science is slowly getting accustomed to it.

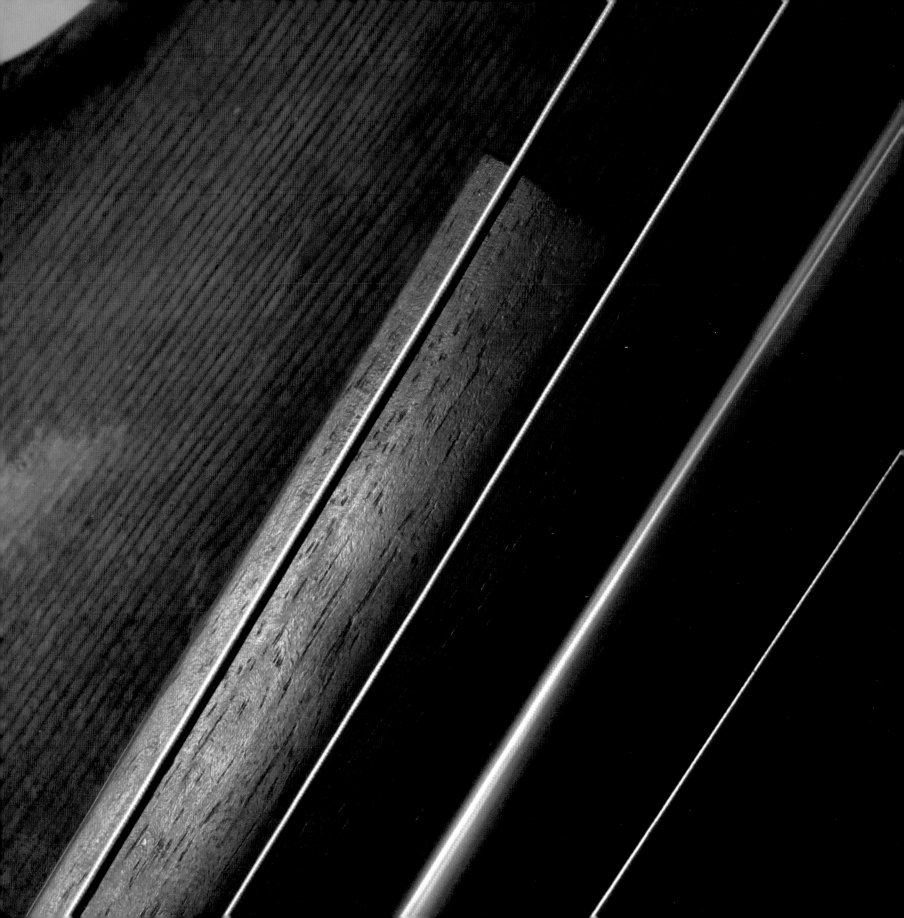

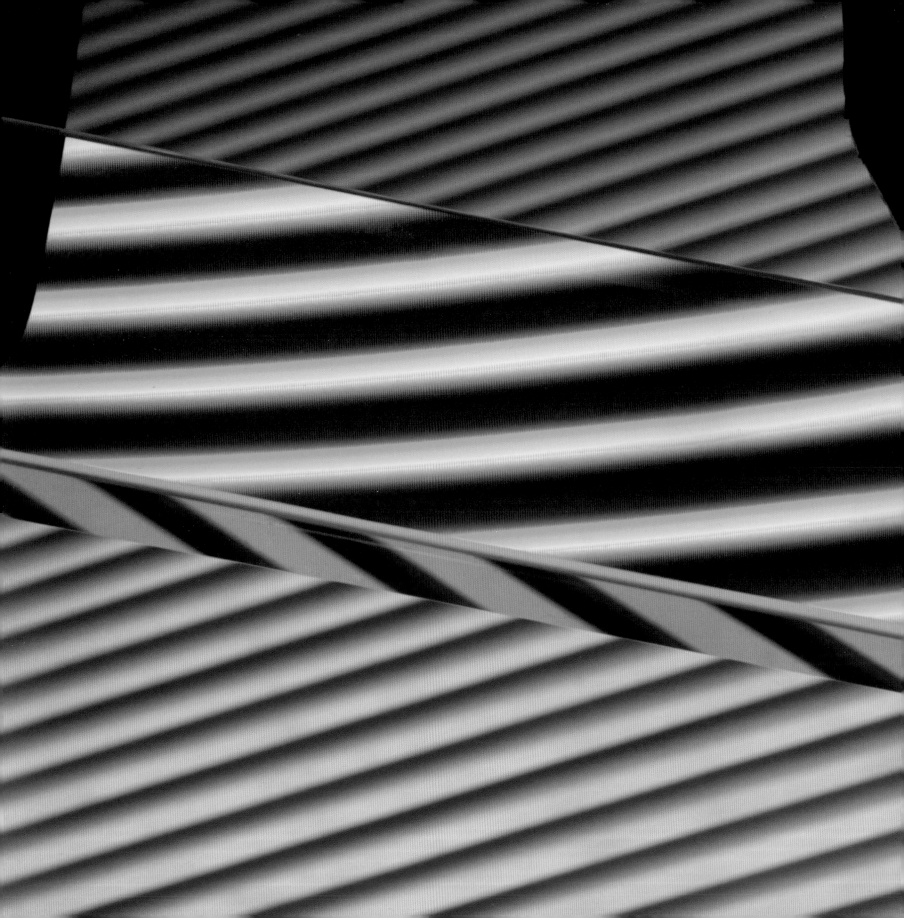

Prism and Diffraction

A SLAB OF WHITE LIGHT becomes a spectral peacock's tail—red, yellow, green, blue, violet—as it bends through a prism. Violet bends the most; red the least. The resolution of white—the mixture of all colors—into separate colors by bending is gaudy. Is it more interesting than that?

Well, what *is* light? Air, water, light, gravity—all parts of reality so familiar to us that we forget to remember them. Light *might* have been anything. Tiny BBs of something; a fog of something else; ripples in a continuous ether of yet another thing. It isn't any of those: it's *light*, which isn't like anything else we know. It's what happens when electrical charge accelerates.

As far as a prism is concerned, light behaves like waves. To understand the details of the conversation between the light and the prism—of the diffraction of light—you have to understand prisms. The general picture is simple enough. To light, a prism is a set of charges—electrons—on springs. (The attractions and repulsions among the electrons and nuclei act like springs.) Light nudges the springs and makes the electrons oscillate; that movement in turn generates light—charges are accelerating—but slightly out of phase. It's like a floating log bobbing with the waves, but not *exactly* with the waves. Imagine light as waves, and imagine that these waves make the electrons in the glass of the prism bob as they pass, and that the bobbing electrons make more, small waves. Add it all up, and you can convince yourself that light should seem to bend as it crosses from air to prism, and bend again in going from prism to air; red light should also bend less than blue. It's a bit like an ocean wave bending around a breakwater, but only a bit.

And there's the odd behavior of light. Going through a prism, or the lens of your eye, it behaves like a wave. Going into your retina, it behaves like a BB. It's a wave when it moves; it's a particle when it hits.

10

WE'RE BURDENED BY A curious conditioning that blinds us to one of the greatest—perhaps *the* greatest—of art forms. We live for poetry; we live in terror of equations.

We see a poem, and we try it on for size: we read a line or two; we roll it around in our mind; we see how it fits and tastes and sounds. We may not like it, and let it drop, but we enjoy the encounter and look forward to the next. We see an equation, and it is as if we'd glimpsed a tarantula in the baby's crib. We panic.

An equation can be a thing of such beauty and subtlety that only a poem can equal it. As an evocation of reality—as the shortest of descriptions, but describing worlds—it is hard to beat the most artful of poems and, equally, of equations. They are the best our species can do.

Equations are the poetry that we use to describe the behavior of electrons and atoms, just as we use poems to describe ourselves. Equations may be all we have: sometimes words fail, since words best describe what we have experienced, and behaviors at the smallest scale are forever beyond our direct experience.

Consider Margaret Atwood:

> You fit into me
> Like a hook into an eye
>
> A fish hook
> An open eye

Consider Louis de Broglie (a twentieth-century physicist, and an architect of quantum mechanics):

$$\lambda = h/mv$$

Read the equation as if it were poetry—a condensed description of a reality we can only see from the corner of our eye. The "equals" sign is the equivalent of "is," and makes the equation a sentence: *"A moving object is a wave."* Huh? What did you just say? How can that be?

It's an idea worth trying on for size. Poetry describes humanity with a human voice; equations describe a reality beyond the reach of words. Playing a fugue, and tasting fresh summer tomatoes, and writing poetry, and falling in love all ultimately devolve into molecules and electrons, but we cannot yet (and perhaps, ever) trace that path from one end (from molecules) to the other (us). Not with poetry, not with equations. But each guides us part way.

Of course, not all equations are things of beauty: some are porcupines, some are plumber's helpers, and some *are* tarantulas.

$$\lambda = \frac{h}{mv}$$

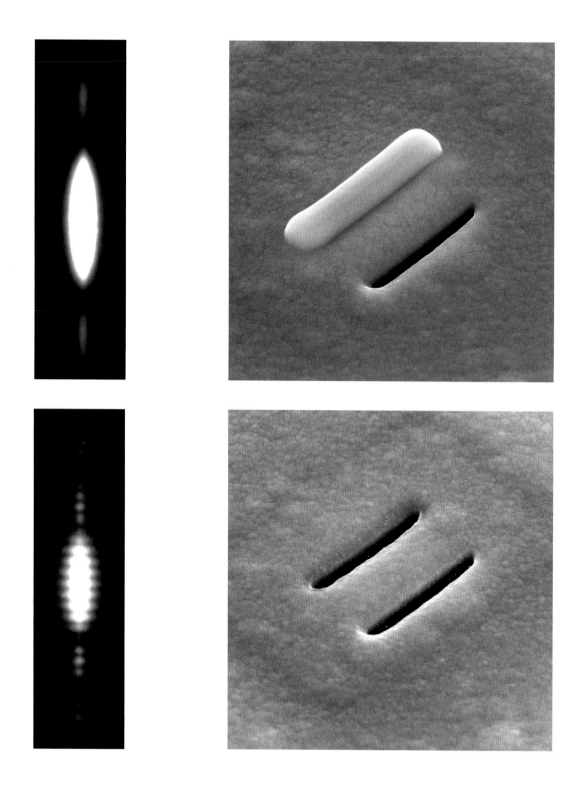

Interference

IMAGINE A BEACH: SUN, WAVES, SAND. Wading in the wash of the waves along the beach—cold water up to the ankles—calms frayed nerves. Waves are unpredictable. If the crest of one wave falls into the trough of another, just a few riffles slither up over your toes; if the crest of a big one falls on the crest of another, it's water up to the knees. That's part of the fun. It's also an example of *interference*—destructive and constructive—between waves.

Science likes to take the world apart and then put it back together. Start with a house; tear it down to boards and nails; use them to build a better house. Each field of science takes one part of the problem. Physics starts with mathematical abstractions and builds to nuclei, electrons, and atoms. Chemistry starts with atoms, builds molecules, and continues to materials and cells. Biology builds organisms out of cells. Sociology builds societies out of organisms. Each field does its thing.

I'm a chemist. My universe is nuclei and electrons, and the almost endless ways they can assemble. Atoms are just at the border between ordinary, macroscopic matter and matter dominated by the Alice-in-Wonderland rules of quantum mechanics. Electrons, in particular, have the unnerving property of having mass and charge but no *extent*—no size. There's no tiny BB down in their core, as there is a nucleus sitting at the center of an atom. "Ah," you say, "that's strange. If there's nothing there, what is it that has a mass? And what's charged?" Good questions.

These images show that electrons—whatever they are—can behave as waves. The smooth oval is an image formed on a detector by electrons going through a single nanoscale slit. The oval with ripples is formed by electrons going through two parallel slits separated by a few nanometers: it's what you expect for interference between waves passing through two channels in a nanoscopic breakwater—the chop in the waves in a quantum harbor. The wave behaviors—including interference—of quantum objects is different from that of ocean waves, but there are also similarities.

As a chemist, I've come to uneasy terms with the weirdnesses of electrons and photons, and with their ability to meld into the ordinariness of macroscopic things. But sometimes, lying awake in a strange hotel room at 4 a.m., considering what I might say that I *really* understand about anything, I fret that the answer is: almost nothing.

Quantum Apple

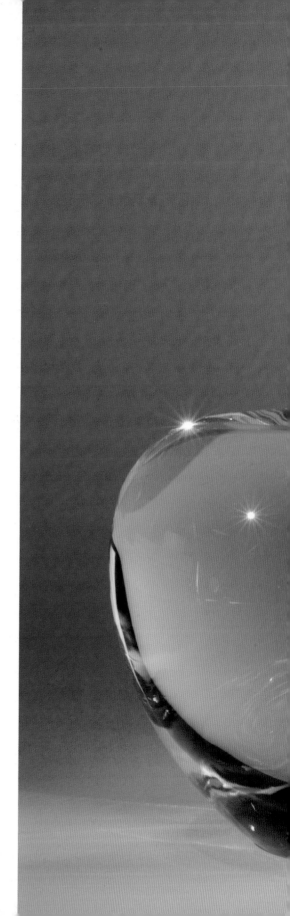

12

HERE'S AN APPLE. It's an interesting, odd, glass apple, but no matter: it's at least the shape of an apple. It casts a shadow.

Fine; but if you look again, you will see that something's wrong. The shadow is not what we expect from an object having the shape of an apple; in fact, it isn't what we expect from anything. Part of it seems to be the shadow from an apple, part from a cube. So what is it? Is there a square cross-section that we can't see? The answer is that the image has been altered; the apple and its two shadows are irreconcilably at odds.

The image is cheating: it gives the appearance of reality but is synthetic—a metaphor for a quantum object, which also has attributes that seem irreconcilably at odds. In our world, a grain of rice is a completely different kind of thing from the ripples on a pond. With quantum objects— electrons, photons, atoms, and molecules—these nice distinctions are not so useful. A thing can be simultaneously a particle and a wave (or it can behave—when looked at in different ways—as a particle or as a wave). In fact, a particle is *necessarily* also a wave. Even you and I are waves, albeit waves with crest-to-crest distances of 10^{-35} cm (a distance so small that it is unimaginable). A quantum apple could perhaps also simultaneously be a quantum cube.

We live in a world of large things. A 10-pound concrete block weighs 10 pounds and is made of concrete, regardless of how we look at it. Small things are more elusive; what you glimpse depends on how and when you look. Even the act of looking changes the thing that is looked at.

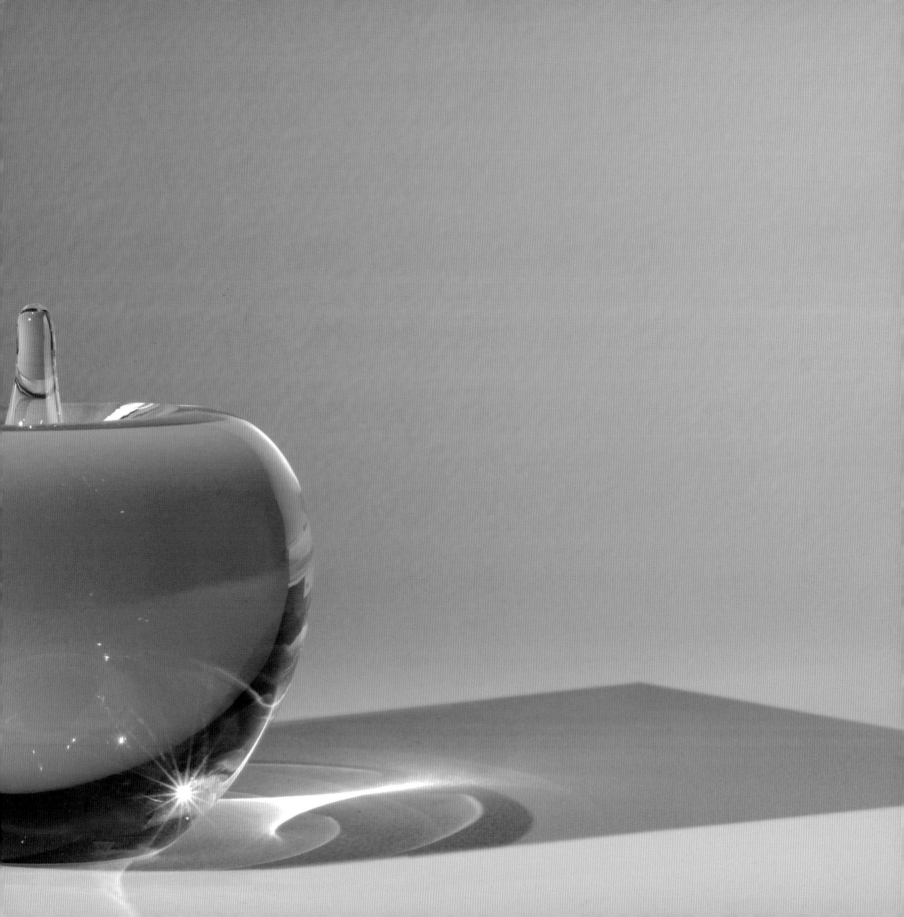

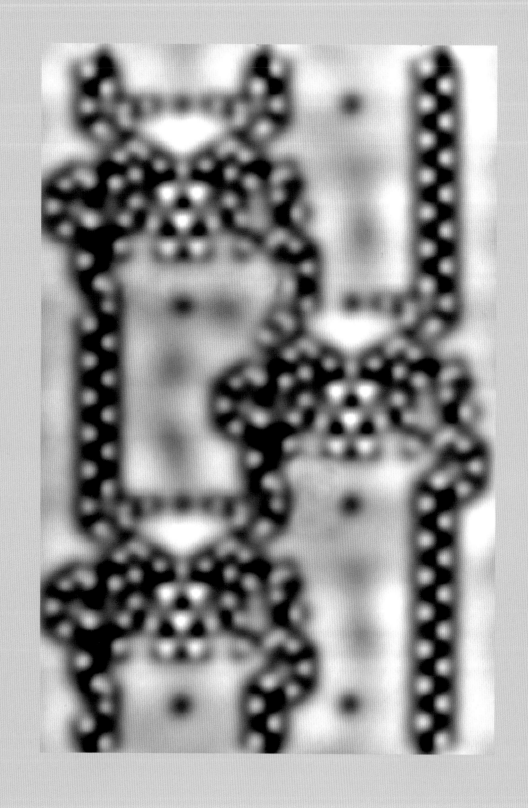

Molecular Dominoes

SWITCHING IS EVERYTHING. When I flick the wall switch, I open an infinitesimal new pathway in the vast circulatory system of the continental power grid, and turn on my bedside light; I give the switch not a second thought. Traffic lights switch the flow of cars at intersections. The message on my voicemail reminding me to put gas in the car requires billions of switches to reconfigure the circuits that route the flows of bits, and let *my* cell phone find *my* trickle of bits in the electromagnetic smog in which I unwittingly marinate. I take a sip of coffee: marvelous networks of nerves in tongue and brain chatter to one another, and connections between them—synaptic switches connecting one nerve cell to another—make my muscles serve my whim.

Anything that controls an output is a switch: a light switch controls electricity, a traffic light controls traffic, and the handle on the shower controls water. All are switches. So, in some circumstances, are an open checkbook or a tentative kiss.

How small can a switch be? How strange can its operation be? This image shows *individual molecules* of carbon monoxide, precariously balanced in patterns on the surface of a metal film: push one, and the next falls over, and then the next. The end result is a cascade that depends on both the pattern and the push: it's like the collapse of cleverly configured molecular dominoes. Astonishing! Molecules behaving like children's toys.

Using metastable arrangements of molecules as a switch is, so far, more a game than a practical solution to a problem. But the *idea*—to arrange sets of molecules to serve as a mechanical switch—is as quirkily wondrous as training fleas to perform classical ballet.

The Cell in Silhouette

14

THE CELL IS THE SMALLEST LIVING THING. What quarks are to physics, atoms to chemistry, and bits to computer science, cells are to biology. They are the stuff organisms are built of. They are as simple as anything in biology; they are as complicated as anything we know.

Much of science starts with the briefest of sketches—the equivalent of a silhouette of Abraham Lincoln, or the Classic Comic version of *War and Peace*—and then fills in details. Here is a kind of silhouette of a mammalian cell. The round part was its nucleus—the container for DNA. The nucleus stores the cell's job description, its instruction set for replication, its memories of its ancestors. The rest was a balloon—the cell membrane—filled with the myriad molecules that give the cell its personality and do its work. The wispy tendrils suggest internal structures. As a silhouette, it's not bad: sack, nucleus, internal machinery.

But this shape—a square—is purest artifact. What biologists study—the cell in a Petri dish—usually has a form that has little to do with the shape a cell would have in an organism. A square is particularly unnatural: this cell has been glued into place using clever chemistry. The cell is probably no more comfortable stretched "square" on a Petri dish than was a heretic stretched "long" on the rack, and its behavior may be no more natural. The relevance of the answers it gives to questions about the normal behavior of cells in organisms is also suspect.

Laminar Flow

WHEN TWO RIVERS MEET, they mix. Eddies form; the swirls carry tendrils of water from one into the other, the tendrils diffuse together, and the rivers lose their separate identities. For two streams of water in microchannels, the rules are different. When they meet, there are no eddies, and they do *not* mix (or do so very slowly).

The flow of fluids in microchannels is *laminar*—that is, the fluid flows as if it were a sheet or slab rather than a liquid. Small channels, low rates of flow, and high viscosities favor laminar flow. The colors in this image are streams of water, flowing in channels approximately 100 microns wide—the width of a hair. The direction of flow is from top right to bottom left.

Arms of a glacier show the same behavior when they meet; so do the slow flows of honey. Even people in narrow corridors move in an orderly stream; being close to a wall keeps everyone in line. If the corridor is wide, people meet, stop, chat, and swirl. Controlling flows in microchannels is vital to microfluidic systems used in biotechnology to analyze blood and urine, to grow cells, and to crystallize proteins that are targets for new pharmaceuticals.

16

WHEN TWO CARS CRASH head-on, shards scatter in every direction. The forces of collision tear metal and shear connections; once a piece is loose, nothing pulls it back into place. It's a chaotic event.

If two streams of *water* collide (albeit with less energy), the results are different and fantastic. In this image, two thin jets of water run into one another almost, but not quite, headlong; (in the photograph, one stream almost hides the other). They deform under impact by spraying laterally into a smooth sheet. The sheet spits out fingers and drops of liquid at its edges, and its core then contracts back into a central stream. The complexity and symmetry of the pattern were completely unexpected.

The difference between cars and these streams of water is partially the energy of collision, partially the way water responds to pressure and gravity, and partially surface tension. When streams of water collide, the liquid responds to the pressure in the region of collision by squirting in the only directions it can: laterally. Gravity also pulls it down. Surface tension—minimization of surface area—makes the sheet contract into fingers and then into drops, and finally collects the remnants of the sheet again into a continuous stream of droplets.

We often associate complex behaviors—the spontaneous formation of intricate patterns, unexpected changes over time—with systems that are themselves complicated. Two streams of water are as simple as one can get, but still—see what happens! Even the simplest systems have the potential to show behaviors that confound us.

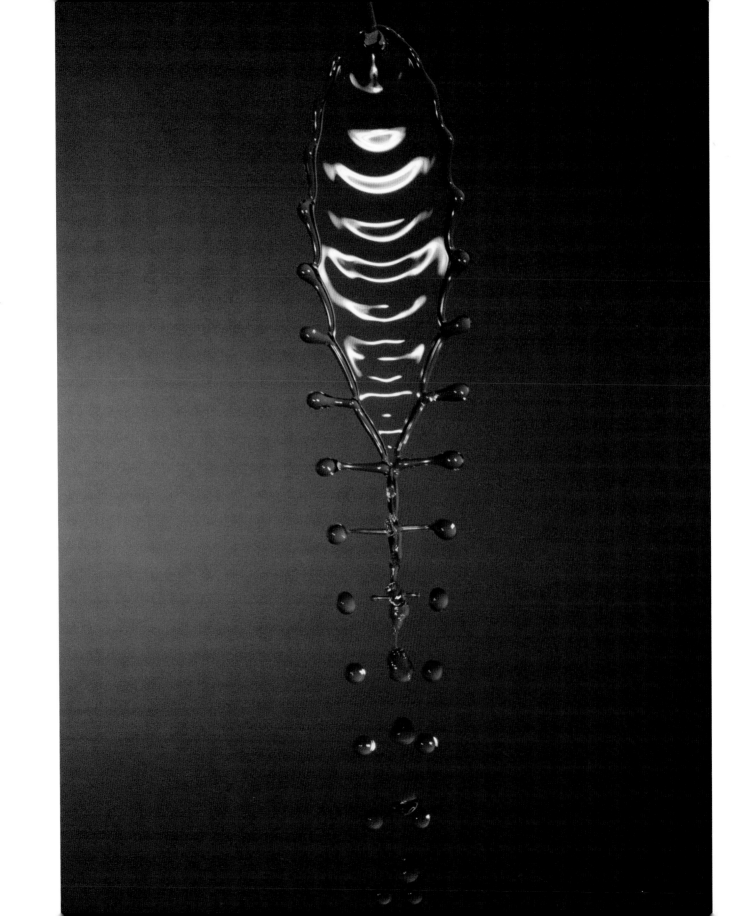

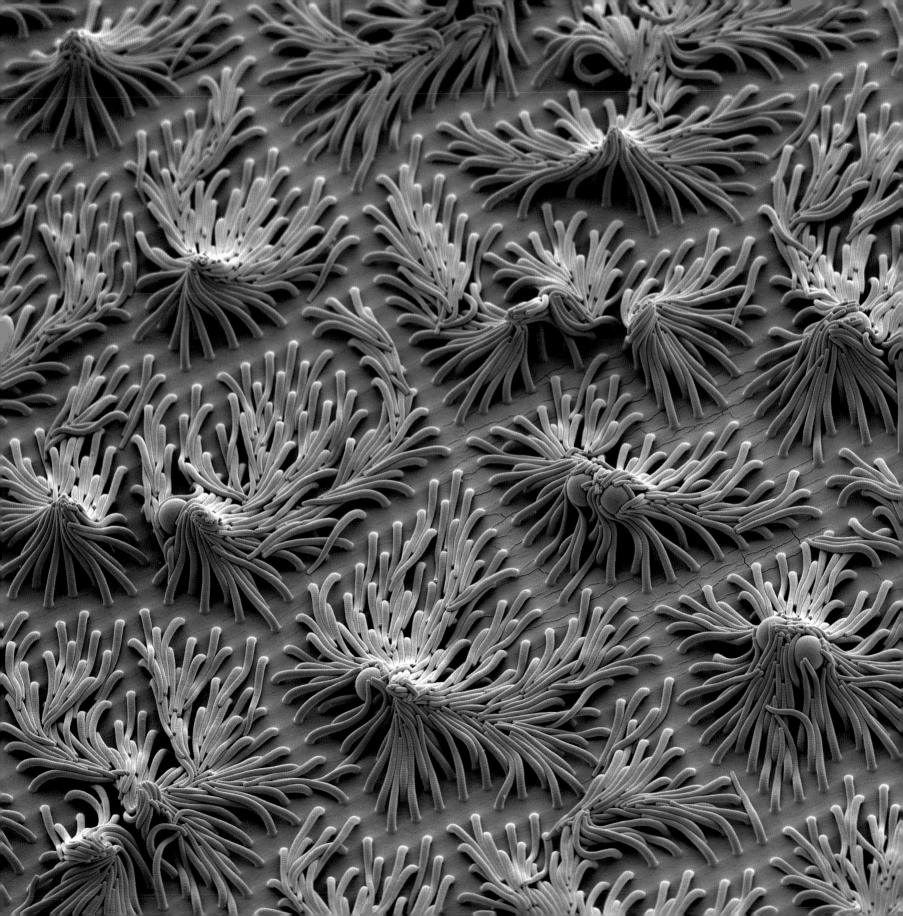

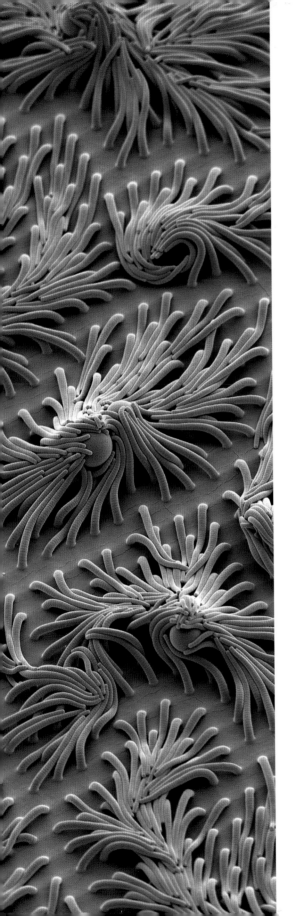

Fingers

MOTHERS SOFTLY SURROUND THEIR children with their arms. Their children grip their favorite ball with all the fierce strength their little fingers can summon. Both are protecting what they love.

These fingers are fronds of polymer—wisps a thousandth the width of a hair. The balls around which they so gracefully drape are small polymer spheres. The spheres originally floated as a suspension in water. A drop of this suspension was placed on the surface sprouting the fronds. As the water evaporated, the spheres settled on the fingers, and capillarity—the tendency for the last, thin film of water to form beads rather than to spread—pulled the fingers to the balls.

It's easy to be confused by inanimate things when they mimic behaviors with which we have emotional associations. Anthropomorphizing capillarity into affection or avarice is misleading but unavoidably appealing.

LIFE

We are each a flame.

A stove burns wood in air. Its heat makes breakfast—fat spitting in the frying pan, water boiling in the kettle.

We burn the sugars we eat (sugars not very different from wood), using the air we breathe. Admittedly, the flame we are heats a million intricately connected pots and kettles, and the meal they make is us: growth, reproduction, aging, personality. We *are* more complicated than breakfast.

And the smoke that curls and twines from our many fires is what we call "society."

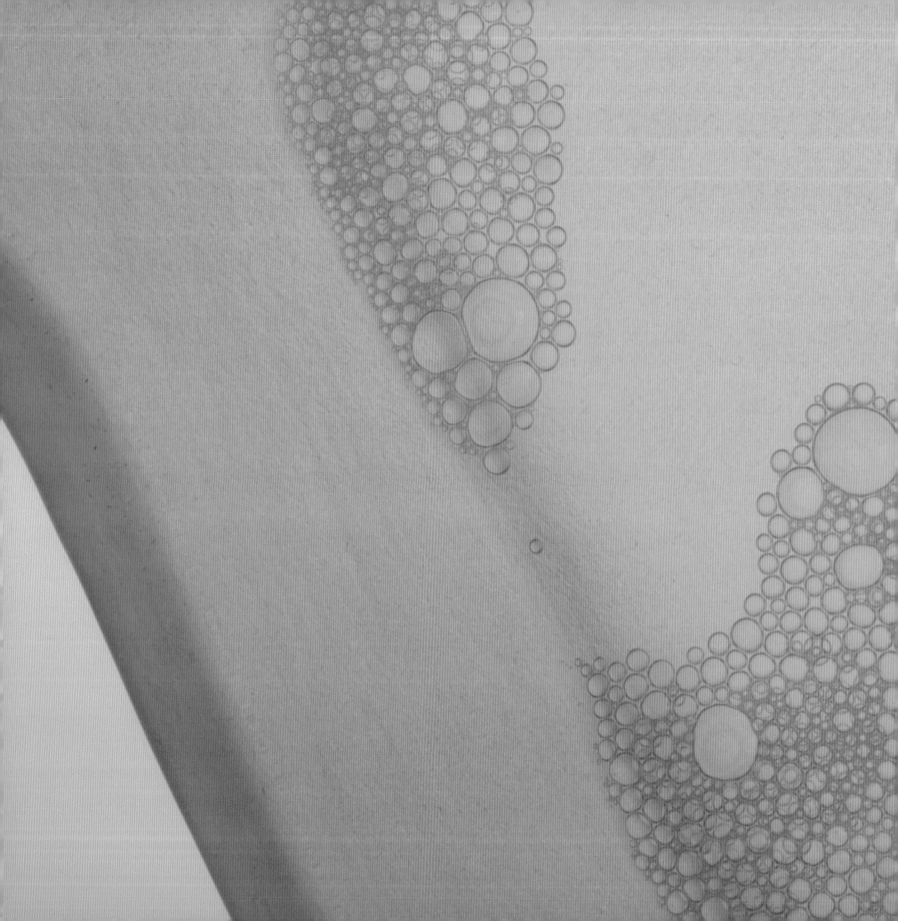

Soap Bubbles

THE FILM THAT DEFINES THE SURFACE of a cell is similar to the film that forms a soap bubble, but turned inside out. Both structures are based on the fact that oil (or fat) and water don't mix.

To get the picture, imagine a molecule of soap as a toothpick whose two ends have incompatible properties: one end is attracted to water, and one to fat. (The molecules in a cell membrane are similar.) When you bring such molecules into contact with water, half of each molecule is *attracted* to the water, the other is *repelled*. How do they solve this dilemma? Remarkably, they start by spontaneously forming molecularly thin sheets, with the fat-loving ends all together on one side and the water-loving ends on the other.

Imagine the result as a piece of bread and butter: the bread (the water-loving part) on one side, the butter (the fat part) on the other. Now, in your mind, bring two bread-and-butter slabs together butter-to-butter: this sandwich suggests a cross-section of the membrane of the cell: on the inside, a very thin film of fat—about two molecular layers thick—with bread on the outside, surrounded by water. Extend this sandwich into a balloon, and you've got the sack that surrounds every cell. The continuous film of fat is what separates the inside of the cell (a solution of biological molecules in water) from the outside (intercellular fluid, which is also mostly water).

For a soap bubble, do the opposite. Put the two layers of bread together with the butter on the outside, in contact with air, and then add a film of water between the pieces of bread. The water is thicker than the bread-and-butter layer—a few thousand molecules thick—but to us, it is still very thin indeed.

Although the basic structures of cell membranes and soap bubbles show two aspects of the same phenomenon—separation of oil and water—the differences are vitally important. The biggest is that a soap bubble is just a film of water and soap, while the cell membrane is studded with other molecules. Some of those open and close like mouths to regulate the furious molecular traffic entering and exiting the cell; some stitch the cell to its neighbors, or to the molecular jelly in which it sits; others monitor what is happening on the outside, and send reports home to the inside.

The Cell as Circus

19

IT IS A NICE SIMPLIFICATION to think of the cell as a balloon filled with salty, watery soup, with some strands of spaghetti called DNA floating in it, and some beans called proteins. As I said, a simplification.

This image shows a cell from the top, splayed out across a flat surface. It has been killed, embalmed, and dyed to make various parts of its anatomy show up. What appears is a little like a photograph of a circus tent. The green strands are molecular ropes: they attach it to the surface, prop it open, and hold it together.

But if it were a circus, we wouldn't see the animals, the clowns, the ringmaster in tails, the beautiful lady in pink-and-sequins-and-feathers on the elephant! And certainly not the egos, quarrels, and intrigues. It is impossible to get a sense for the vitality of the circus—of the roles and idiosyncrasies of the animals and the performers—from a satellite picture of an abandoned tent. It is impossible to appreciate the elegance and feverish activity of the cell from its image after it has been pickled and rouged.

There are many ways other than microscopy to understand cells. DNA sequencing opens a kind of sketchy instruction book. Analysis of proteins says who the workers are, but only hints at what they do, and says nothing about how they work together. We can't tell the bosses from the animals. The ticket takers operate using an arithmetic we do not understand.

It's all quite mysterious. But then we are all still rubes at this circus, and dazzled by all the action.

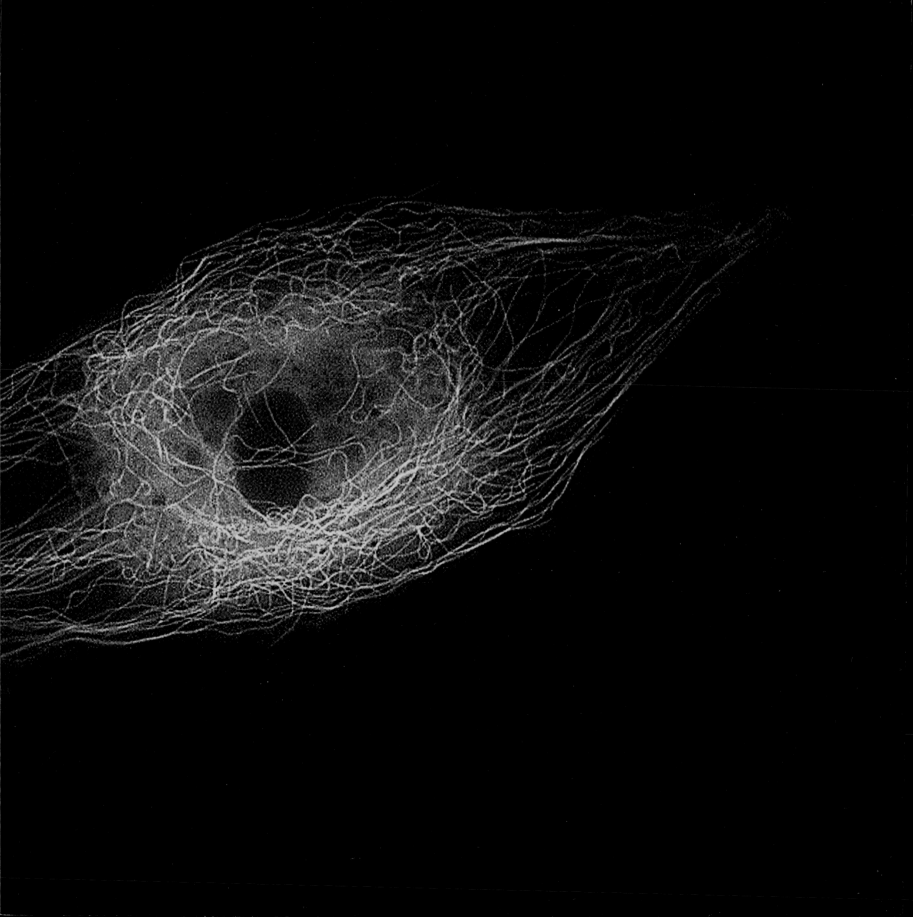

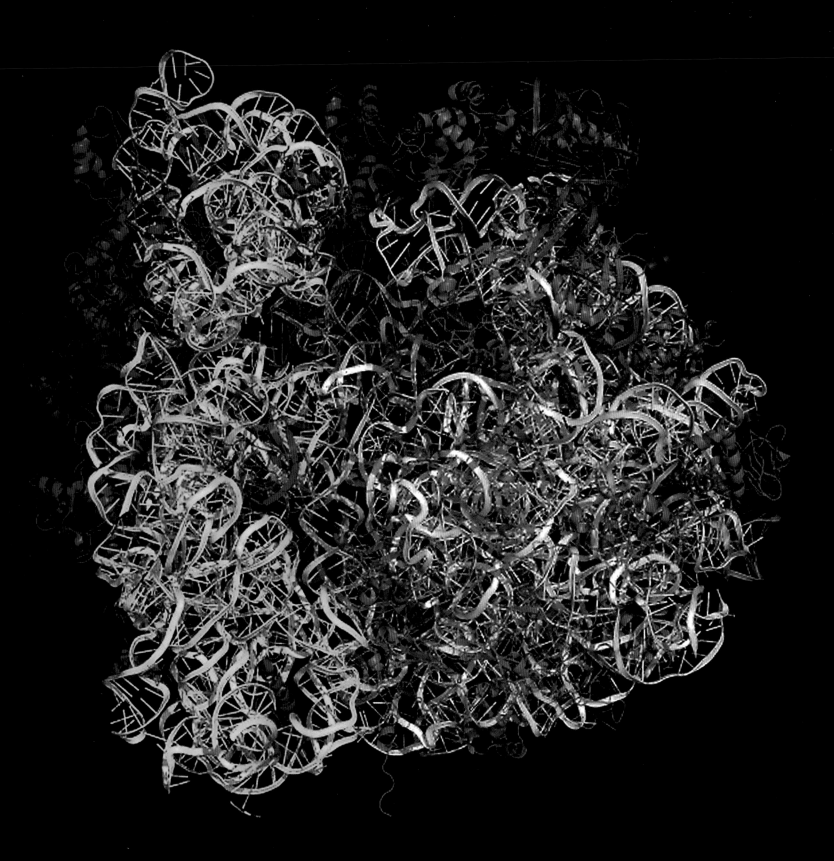

Ribosome

THE CELL CONTAINS MANY molecules that carry out nanometer-scale operations more complex than the meter-scale jobs robots do on an automobile assembly line. The ribosome (of which this image shows only a part) is one. It is among the largest functional molecular structures we know—an aggregate of protein and RNA perhaps 20 nanometers in diameter. This molecular hairball is impossibly complicated—the accretion of parts and patches from billions of years of Darwinian optimization.

The belly of the cell is a scene of organized molecular chaos. Here, the ribosome finds and inserts into itself a disposable molecular tape (messenger RNA, transcribed from DNA), and uses its instructions to synthesize an entirely new sort of molecule (a protein), by adding twenty component pieces (molecules called amino acids), one at a time, in sequences dictated by the RNA, to a growing string. All this at rates of hundreds of additions per second.

The ribosome assembling proteins has an advantage over a robot assembling cars—the parts it uses float in the water that surrounds it: it does not contend with gravity or conveyor belts. It also has no controlling computer: it somehow operates autonomously, according to molecular principles we can vaguely appreciate but cannot even faintly mimic. The obvious question is: How did evolution produce a structure of this enormous complexity and sophistication?

The answer is: We don't know. The evolution of the ribosome is a tale of trial and error that has been developing for several billion years. Darwin sketched the storyline for us, but we are reading Chapter 100 without being able to read Chapter 1. As with any great story, Mr. Darwin's excellent idea has layers of subtlety that we have not yet even recognized, much less understood.

Bacterial Flagella

21

WE UNDERSTAND INTUITIVELY how submarines move. There's a hull, a motor, a shaft, and a propeller. Straightforward. The motor turns the shaft; the shaft turns the propeller; the propeller pushes against the water; the submarine goes forward. We can simulate the forces on the propeller blade by moving a hand rapidly through the water in a swimming pool.

Our intuitions about the behavior of water on a large scale fail for water on a small scale. To a bacterium, water is like cold honey; a turning propeller moves it nowhere. So it uses a strategy very different from that used to move a submarine. The bacterium has many motors, and each turns a long, flexible, helical whip called a flagellum. When all the motors turn in the same direction, the whips wind themselves into an orderly helical bundle: as it spins, it drills the bacterium forward. This bundle is more like an auger than a propeller.

A bacterium has no steering motor and no rudder. It changes direction by turning several of its motors into reverse. The helical bundle unwinds, and the bacterium spins randomly. It then puts all of its motors into "forward" again, and sets off in whatever direction it happens to be pointing.

It sounds hopelessly inefficient; but there are uncountably more bacteria on earth than there are humans. They are small and many; we are large and few. In the end, they eat us. Who is more efficient? Who wins?

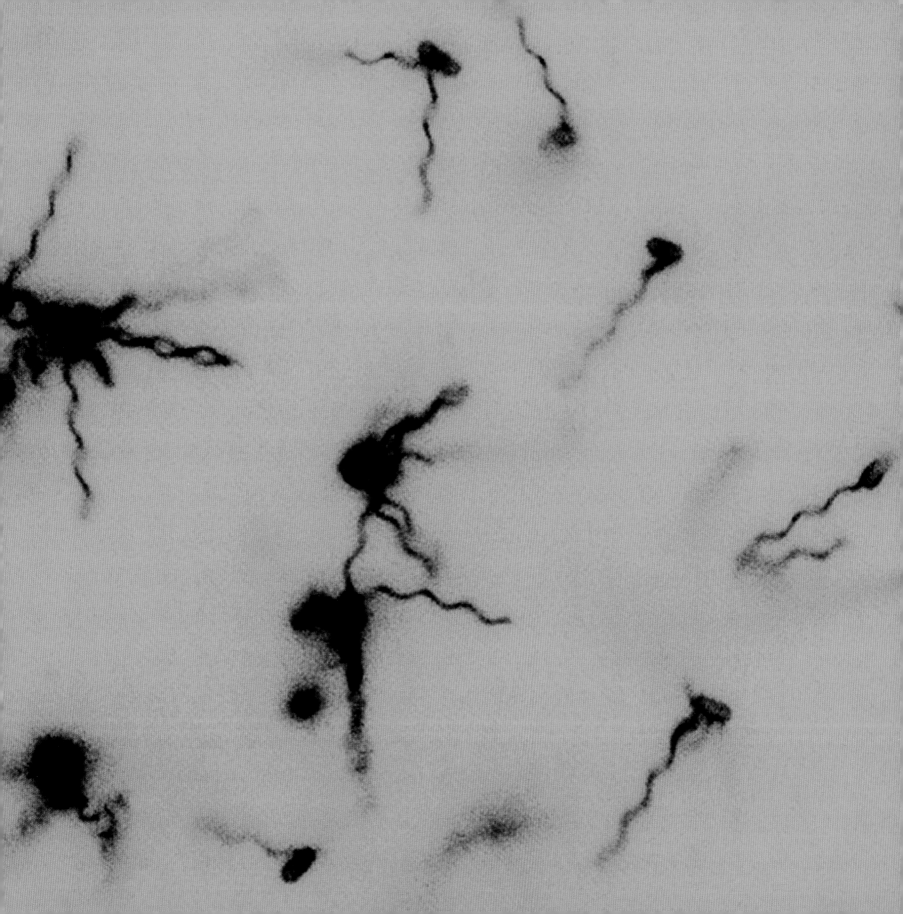

Life as a Jigsaw Puzzle

THE SIMPLEST POSSIBLE VIEW OF LIFE—of the cell—is that it is a kind of jigsaw puzzle. The pieces are molecules. When they fit together correctly, life happens.

But there's more to it than that. First, imagine that most of the pieces are not flat but three-dimensional, rubbery, and only nanometers in size: Jell-O molded into complex shapes, rather than cardboard cut into primitive ones. To fit together, the shapes must be complementary: the hand must slide into the glove, and while a six-fingered glove might do for a five-fingered hand, a four-fingered glove would not. And "complementary" involves more than just shape—some patches of the surfaces are sticky, some slippery, and some colored, and these patches must also match.

All of which is complicated enough, but there is more. When the pieces come together, even when everything matches, they usually don't stick for long. (And incidentally, they are trying one another out for fit rapidly: every piece bumps its neighbors about a hundred billion times per second. Speed-dating in the fast lane.) Disconcertingly, when they separate, they may have changed into other pieces. So, if life is a jigsaw puzzle, it's a multidimensional puzzle of enormous complexity, with countless shape-changing pieces colliding and interconverting in a blur of activity.

And by the way, the puzzle also is carnivorous: feed it pieces of other puzzles, and it digests them into its own, and occasionally splits itself into two almost identical puzzles.

We've also left out the water: all of this molecular scurrying-around takes place in the company of other pieces—water molecules—which sometimes stick and get in the way, and sometimes act as glue or lubricant. We know that water is absolutely vital, but what, exactly, does it do?

We really don't understand how it all works.

As the Wheel Turns

23

MOST OF THE MOTORS we build rotate a shaft around its axis. Rotary motors—electric motors and internal combustion engines—are perfect for turning wheels, and we are addicted to wheels.

What about bacteria? They do not have wheels, but they churn through water quite handsomely. What motor powers *them*? We infer from this ghostly cross section that bacteria also use rotary motors, but not like ours. The bacterial motor does have a rotating shaft, and a kind of stationary outer shell or bearing (shown here), braced somehow in the cell membrane. But its components are made of proteins—soft, intricately folded molecular threads—rather than hard, shaped metal. It runs on a current of protons rather than electrons; it turns a flagellum, not a propeller.

Yet it works! A bacterium at "full steam ahead" travels its own length more quickly than does a submarine. The bacterial motor is an inspiration for engineers: it is a fully formed, functional nanomachine, working in ways that we might never have considered. The bacterium pumps protons (H^+) out of its body and across its membrane, and thus creates a difference in their concentration between the inside and the outside. The protons can flow back into the cell by passing through the motor; when they do, the shaft ratchets forward, pushed by changes in the shape of its proteins. The process seems clunky—like pumping water uphill, so it can run down again to power a water wheel—but it is the one natural selection favored.

Nanotechnologists have argued fiercely about motors for decades. One of the early promises of the futurists was "little submarines": nanomachines circulating in the blood, hunting cancer cells. Micron-scale hunters *do* exist in our bodies (cells called lymphocytes), but they resemble a submarine no more than a cat resembles a lawnmower. Still, nanoscale flagellar motors propel micron-scale bacteria rapidly through water. These motors are wildly different from anything we have designed.

The flagellar motor is one of a flotilla of nanomachines with designs astonishingly alien to our intuition. But evolution has been throwing the dice—randomly testing designs—for millennia, with spectacular success. Among our tasks is to develop the humility and sophistication to learn from this master engineer.

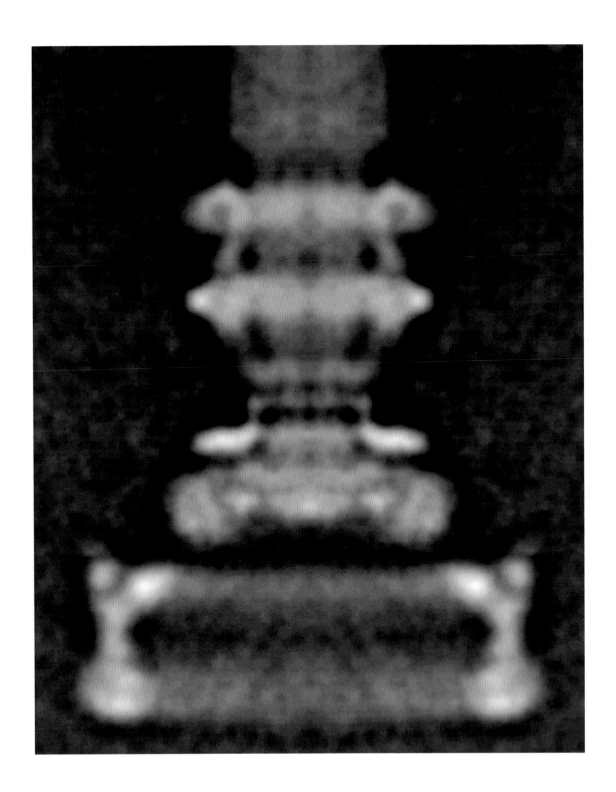

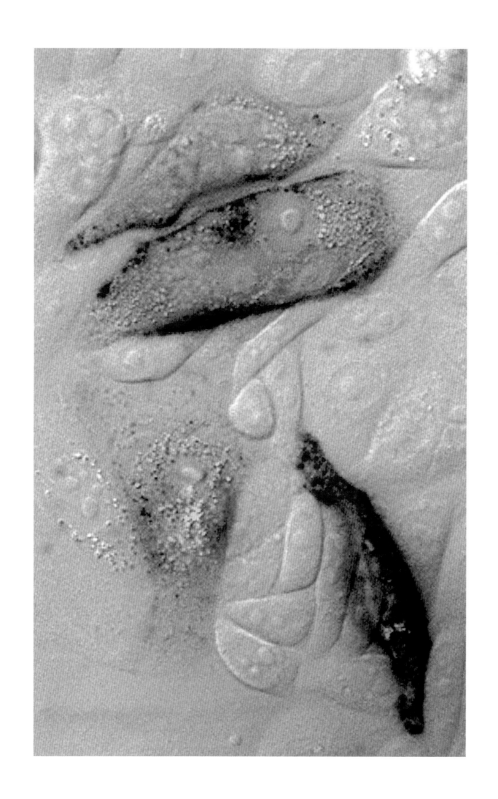

Quantum Dots and the Cell

WHACK A TUNING FORK GENTLY on your knee; it softly sings a single pure tone. A harder hit makes the same tone, just louder. This tone—that is, the frequency of the tuning fork's vibration—is independent of how hard it's hit.

Quantum dots (nanometer-sized spheres of inorganic materials such as cadmium selenide) behave similarly—although for a different reason. Shine ultraviolet light on a quantum dot, and it emits visible light of a particular color. Increase the intensity of the ultraviolet light, and the emitted light becomes more intense, but the color stays the same. The oscillations that produce the colors emitted by quantum dots are not the mechanical oscillations of a tuning fork, but the more subtle oscillations of their electrons.

Quantum dots are useful for two reasons. First, their *size* determines the color they emit: little dots emit in the blue; big ones in the red; medium-sized ones in between. It's easy to produce any color by just changing the size of the dot using clever synthesis. Second, to see the structures in mammalian cells by microscopy, we usually need to use dyes; most parts of a cell are transparent, uncolored, and invisible. Many dyes tend to bleach during examination in the microscope; quantum dots don't.

In Thailand, at night, fireflies collect in particular trees, and their flashing—sometimes astonishingly synchronized—shows the shape of the tree and the structure of its branches. This image shows colors emitted by quantum dots in cells (superimposed on a microscopic image of these cells). Different colors correspond to dots of different sizes. They have been tailored, like nanoscopic fireflies, to outline specific structures in the cell.

Sequencing DNA

DNA IS A CELL'S INSTRUCTION BOOK. Reading the letters and words in this book is no longer a problem, nor is it difficult to find the sentences. Understanding what a sentence *means*, and following the structure and plot of the book, remain largely beyond us.

The DNA tells the cell how to build proteins—the molecules that do its work. Proteins are made by stringing beads together; the beads are smaller molecules called amino acids, and they come in twenty different structures. The "alphabet" of DNA is simple: it has four letters, A, T, G, C—the "bases" of the genetic code. The "words"—the specifications of the next bead to add—are also easy: each is three letters. The "sentences"—the descriptions of complete proteins—are much more complicated: hundreds of words, which are sometimes mixed with sections that seem to be gibberish, sometimes scrambled with bits of other sentences, and sometimes extensively revised by unseen editors to change their meaning. With work, we can parse the sentences, but we really can't decipher what they say—what the proteins do. When we try to interpret the whole story— to understand "life"—we are like children facing *Finnegan's Wake*. We suspect there is a plot, but we have no clue what it is.

Reading the story of the cell by reading its DNA is still a little like trying to understand a city by reading its telephone books. Telephone books give names, numbers, and addresses, but tell nothing about the people: what they do, who they talk to, what their favorite flavor of ice cream is, who works for government and who sells groceries. Nor do they tell how the people form a city. The DNA tells what some of the proteins are, but not what they do, how they communicate with one another, or (the *real* question) how the cell becomes "alive."

Reading DNA is fun and easy. Every biologist does it. The results are certainly instructive, and are becoming useful. Because DNA sequencing is so important, there are many technologies that do it rapidly and accurately.

CAATGGTTCAATGGTTGGTCAAGGATGCGCAACCCAATGATTCTTTGTTCCTTCATTA
GGTGGCCAGGTGGCCAAACTGAAGATTCGGATGGGGACGAAGAAGATGGGATGGCACGATATAATGGTAC
CCGGTCGACCGGTCGATTTCGAAACTCAAGGTGTTAGACTAACAGCATTGTTTGACTCTTGTCATTCGGGTACA
AAGCCCTTAAGCCCTTACAACAAGGTGTTGGATCTTCCATATACCTATTCTACTAAGGGTATTATTAAGGAGCCCAATATTTGG
GTGTTGGAGTGTTGGATCTTCCATATACCTATTCTACTAAGGGTATTATTAAGGAGCCCAATATTTGG
ATTCTCAGATTCTCGTGCTGTCGAGATAATCAAACTTCTCGCAGATTTACAACCGCTGGTGGTAATAATGGCTACCAA
TGCTGTCGTGCTGTCGAGATAATCAAACTTCTCGCAGATTTACAACCGCTGGTGGTAATAATGGCTACCAA
TTTACAACTTTACAACCGCCTTCATCAAGGTTACACCTACAACATGGACAGCAATTCAGTCAGCAATATCAATTC
ATGTATCCATGTATCCATGGCTCCTCCACCTAACCAGCAACAAAATGATCAGGCCTGTGTATCCCCCCCTCAATTC
CGGCCCATCGGCCCATGGACAGCATGGACAGCCCCCTATGGCAATTAAGCAACGGCTACAACAATCAAACACAAACTAT
CAGCAGTACAGCAGTACCCCACCAGGTCCTCCCCCAGAATATTCTCAATGCGTGGTTGTATCAATGATGCTAT
CCACCACCCCACCACCCCAGGTCCTCCCCCAGAATATTCTCAATGCGTGGTTGTATCAATGATGCTAT
CAGCAGGACAGCAGGAACAGGTCCTCACCCGCAAAGGCACAATTAAGCAACGGCTACAACAATCAAACACAAACTAT
TCCAATATCCAATATTCCAATATGGGTACGGTCAAAGGCACAATTAAGCAACTGCGTGGTTGTATGATGACATTGTCATATT
CAAGGTACAAGGTACCAAGGTATAAACTACATAGGTTCAAAAAATCAACTGCGGTTACAGTTCAGATAATGATTAGGGCCATG
ATCGGTATATCGGTATATCGGTATAAACTACATAGGTTCAAAAAATCAACTGGTTACAGTTCAGATAATGATTATTCTGGACA
AACATCTTAACATCTTCAACTTTTTGACTAATGGGTACGGGTTCCCACTAGGGCTAAATATGATTATTCTGGACA
ACTGATGAACTGATGATCAGAACGATTTGGTCAAGGATGCGCAACCCAATGATTCTTTGTTCCTTCATTATGATGTTATAT
CAATGGTTCAATGGTTGGTCAAGGATGCGCAACCCAATGATTCTTTGTTCCTTCATTATGATGTTATAT
GGTGGCCAGGTGGCCAAACTGAAGATTCGGATGGGGACGAAGAAGATGGGATGGCACGATATAATGGT
CCGGTCGACCGGTCGATTTCGAAACTCAAGGGCCAATTATCGACGATGAAATGCACGATATAATGGTACA
AAGCCCTTAAGCCCTTAGACTAACAGCATTGTTTGACTCTTGTCATTCGGGTACA
GTGTTGGAGTGTTGGATGTTGGCCAAGATGGCCTGTATATTCAGCAGCTATTTCATATGCCACAGGAAACAGGGCAATAAT
AAGGATGTAAGGATGTTGGCCTTTAGGTTCTATATTCAGCAGCTATTTCATATGCCACAGGAAACAGGGCAATAAT
GCTTTGATGCTTTGATTGGTTCTTTAGGTTCTATATTCAGCAGCTATTTCATATGCCACAGGAAACAGGGCAATAAT
GTGGATAGGTGGATAGAGAACGCGTGAGACAGATCAAATTCTCAGCAGCAGATGGGCAAAATACAGGTGCA
GGTTCGAAGGTTCGAAGGATAATCAAACTTCTGCAGATTTACAACCACAGCAATCATATTTATCTCTT
ATGTCCCAATGTCCCACGCCTTCATCAAGGTTATGACTTTACAACCACAGCAATCATATTTATCATGG
TTACAGAATTACAGAACATGAGGAAAGAATTGGCTGGTAAGTATTCTTGTCACACCCTATTGACGTAA
TCACACCCTCACACCCTCACACCCTATTGACGTAAATACAGCATTGTTTGACTCTTGTCATTCGGGTACAAGCATTGT
CAACAAGGCAACAAGGCAACAAGGTGTTAGACTAACAGCATTGTTTGACTCTTGTCATTCGGGTACAAGCATTGT
CTTCCATACTTCCATACTTCCATATACCTATTCTACTAAGGCAGCTATTTCATATGCCACAGGAAACAGGGCTAGCTATT
GGCCAAGAGGCCAAGAGGCCTGCAAGCAGCTATTTCATATGCCACAGGAAACAGGGCTAGCTATT
GGTTCTTTGGTTCTTTAGGTTCTATATTCAAGACCGTTAAGGGAGATGTTGTTATGTTATCAATTCTCAG
GAACGCGTGAACGCGTGAGACAGATCAAATTCTCGCAGATGCTGTCGAAGATGGGCAATCATATTTATCATCG
GATAATCAGATAATCAGATAATCAAACTTCTGCAGATGCTGTCGAAGATGGGCAATCATATTTATCATCG
GCCTTCATGCCTTCATCAAGGTTATGCTGGTAAGTATTCTTGTCACACCCTATTGACGTAAATTATTAT
ATGAGGAAATGAGGAAAGAATTGGCTGGTAAGTATTCTTGTCACACCCTATTGACGTAAATTATTAT
ATTGACGTATTGACGTATTGACTAACAGCATTGTTTGACTCTTGTCATTCGGGTAC
AGCATTGTAGCATTGTTCAACAAGGTATACCTATTCTACTAAGGGTATTTCATATGCCACAGGAGGTATGGGCAATAA
TAAGGGTATAAGGGTATAAGCTATTTCGGCCAGACCGTGGTTCTTTGGTTCTATATTCAGCAGCTATTTCATATGCCACAGG
AGCTATTTAGCTATTTAGCTATTTCGGCCAGACCGTGGTTCTTTGGTTCTATATTCAGCAGCTATTTCATATGCCACAGG
CAAGACCGCAAGACCGCAAGACCGTGGTTCTTTGGTTCTATATTCAGCAGCTATTTCATATGCCACAGG
ATTCTCAGATTCTCGTGCTGTCGAGATAATCAAACTTCTCGCAGATTTACAACCACAGCAATCATATTTATCAAA
TGCTGTCGTGCTGTCAACTTTACAACCGCCTTCATCAAGGAAAGAATTGGCTGGTGTAAGTATTCTTCAGGCTGGTAA

Molecular Recognition

LITTLE CHILDREN HAVE AN unerring sense for how to find their parents at a party. They sort through the forest of knees until they find the pair with the right shape, and then wedge themselves between them. Children are very successful in doing what they set out to do: to block a dysfunctional behavior (grownups paying attention to grownups) and cause more useful behavior (parents paying attention to children).

Molecules in the cell do the same. They find one another and stick together—one wraps *around*, and the other wedges *in*. If they do it correctly, the cell lives; if they make mistakes, the cell dies. How does it work? How do they find one another? What holds them together?

Molecules have shapes, and the fitting together of complementary shapes—*molecular recognition*—is part of the answer. But there is more to it than simply shape. A familiar hand is not just five fingers; it is also texture, and strength, and warmth, and calluses.

So it is with molecules. Some parts of their surfaces are electrically charged; some attract water, some repel it; some are rubbery; some are stiff. And importantly—perhaps *most* importantly—they are surrounded by water. We know that water, and the interactions of water with the molecules dissolved in it, are key to molecular recognition, but we do not understand how.

The large textured surface in this image is a computer's view of a protein (a few nanometers in diameter) indispensable to the synthesis of cholesterol. Too much cholesterol, and our arteries plug, with dire consequences. The small blue object is a drug called a statin, a drug that slows the rate of synthesis of cholesterol in the body. Many older people would be dead had not the statins they take daily found the right proteins and wedged themselves between the proteins' knees.

Molecular recognition is perhaps the most fundamental single process in biochemistry. Everything in the cell depends on it—from reading the information in DNA correctly, through making properly folded proteins, to regulating metabolism. It is even more fundamental to the functioning of the cell than parents are to the functioning of their children.

Harvesting Light

As Beethoven aged, he grew deaf—a serious problem for anyone, but especially for a musician. An ear trumpet was a partial solution. It was a tuba in reverse: the wide end collected sound, concentrated it, and funneled it to his fading ear. Scratchy whispers become muffled shouts.

Plants have a problem related to Beethoven's. Sunlight is vital to them—the food on which they live—and sunlight is dilute. What is bright to our eyes may not be bright enough for a plant. It uses a solution similar to Beethoven's. Its leaves contain marvelous, complex structures of molecules that are—in essence—ear trumpets for light. These circular structures absorb red light (and reflect green, so we perceive leaves as green) and funnel the energy from the absorbed light to even more complex structures at their center. These then begin the intricate, multistep process of generating oxygen from water, and synthesizing from carbon dioxide the sugars the plant uses to build itself.

Those of us who love Beethoven's music benefited from his ear trumpet (the one in this image is *his* trumpet—the one Beethoven himself used). Everyone—including Beethoven—has depended on the "light harvesting trumpet" of plants, since it makes possible all that we eat and all that we breathe.

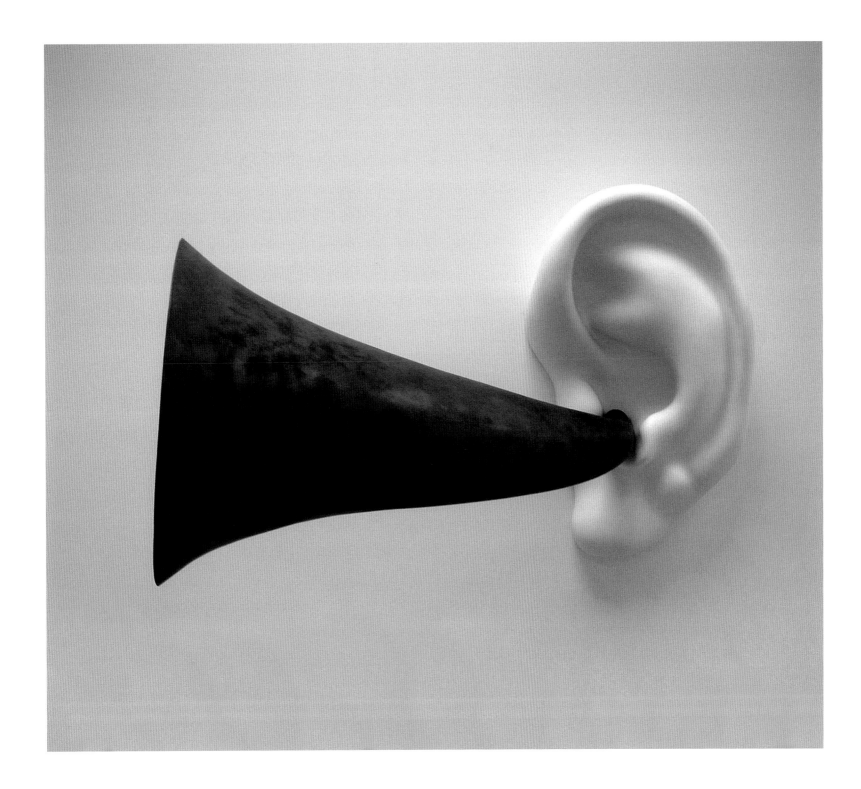

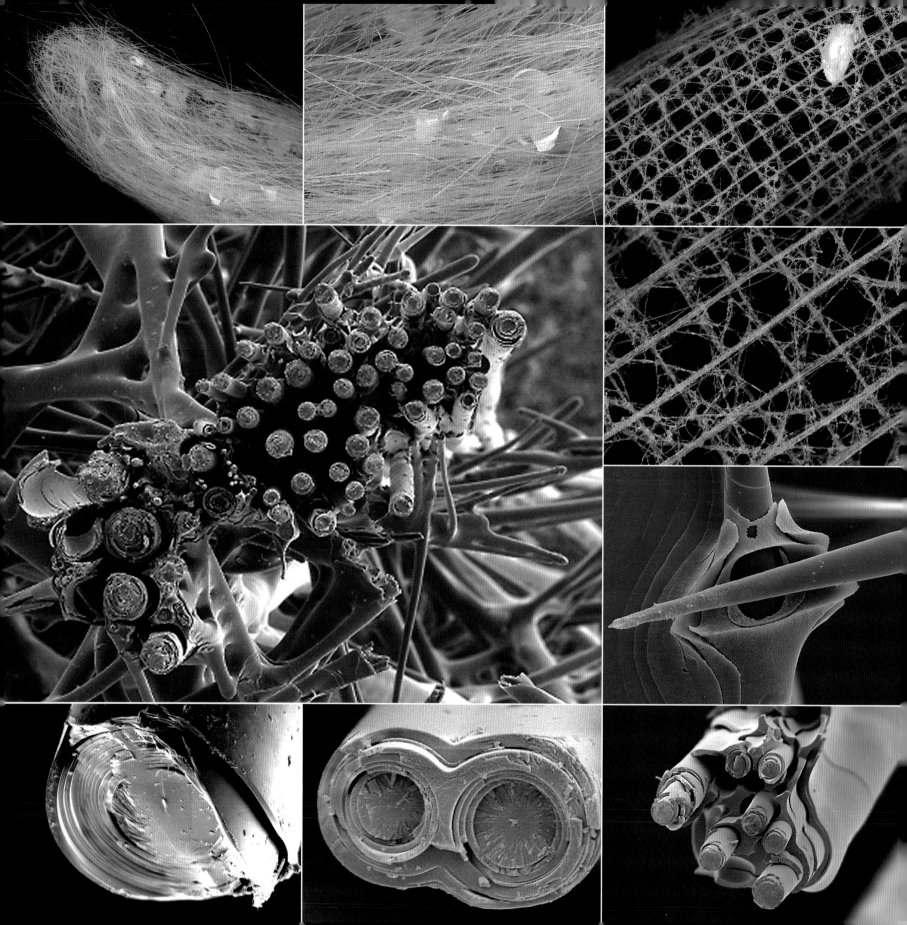

The Elegance of Simple Animals

IN THE OCEAN LIVE CREATURES of many complexities. We focus our admiration on the intellectuals: squid, porpoises, whales. They are the ones who would—in a different world—easily beat us at three-dimensional chess or oceanwide choral singing, and already do a better job of evading sharks. We are amazed at the subtlety of their sentience. We sometimes enjoy eating them.

But what about the creatures that are less smart? The ones with no brain, no eyes, no mobility, no Disney-ready personality? Have they no tricks worth our admiration?

The image on the following page is the skeleton of a sponge called Venus's flower basket (*Euplectella aspergillium*). This blob of a creature builds for itself an intricate, hierarchical cage of silica (here, the cells that covered this structure when the sponge was alive are gone). In this cage, the sponge traps two shrimp (he and she), who spend their lives there, both protected and imprisoned. The relationship between the sponge and the shrimp is complicated, as are most *ménages à trois*. The cage seems to protect the shrimp; the sponge and shrimp somehow help one another to feed.

Each element of the cage is composed of smaller elements, and at each scale of size there are astonishing and unexpected details of design, construction, and interweaving of elements. For example, the struts—the "spicules"—simultaneously provide mechanical strength and transmit light generated by phosphorescent bacteria in the base of the organism to its rim—perhaps the neon lighting of an abyssal Hotel California for passing prey. "You can check out any time you like, but you can never leave."

This design is as elegant as anything engineers can conceive, and its fabrication—particularly since the sponge has nothing even faintly resembling a brain, and no raw materials to work with other than seawater—is beyond the best that engineers can do.

We do not eat it.

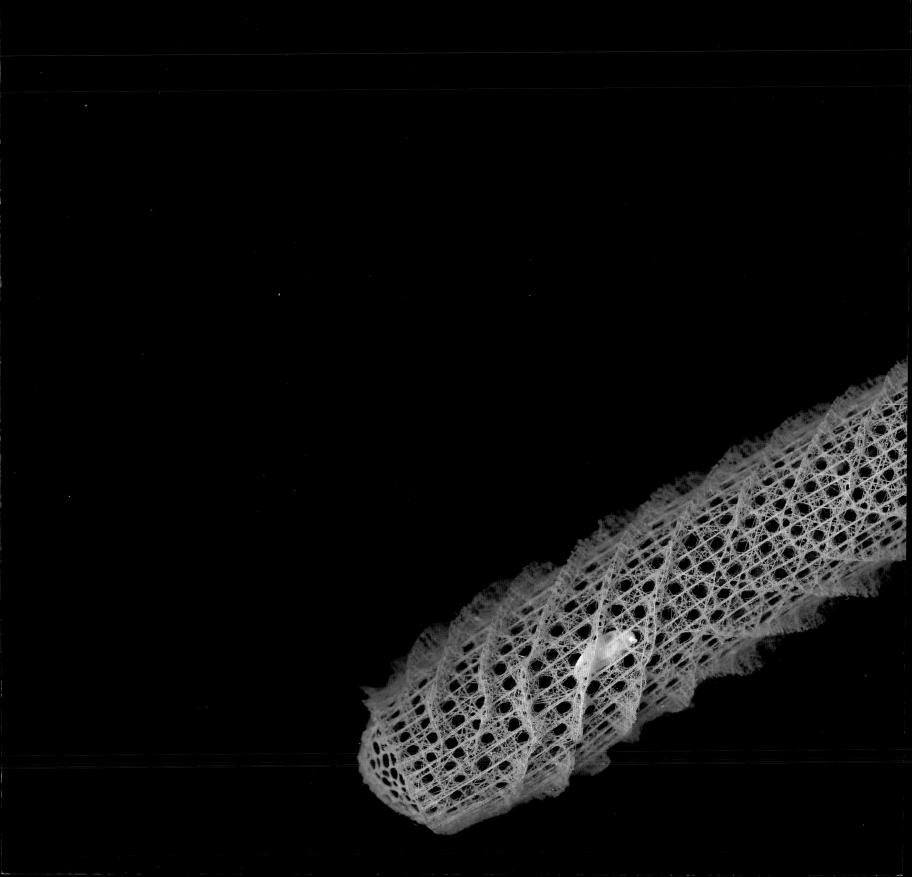

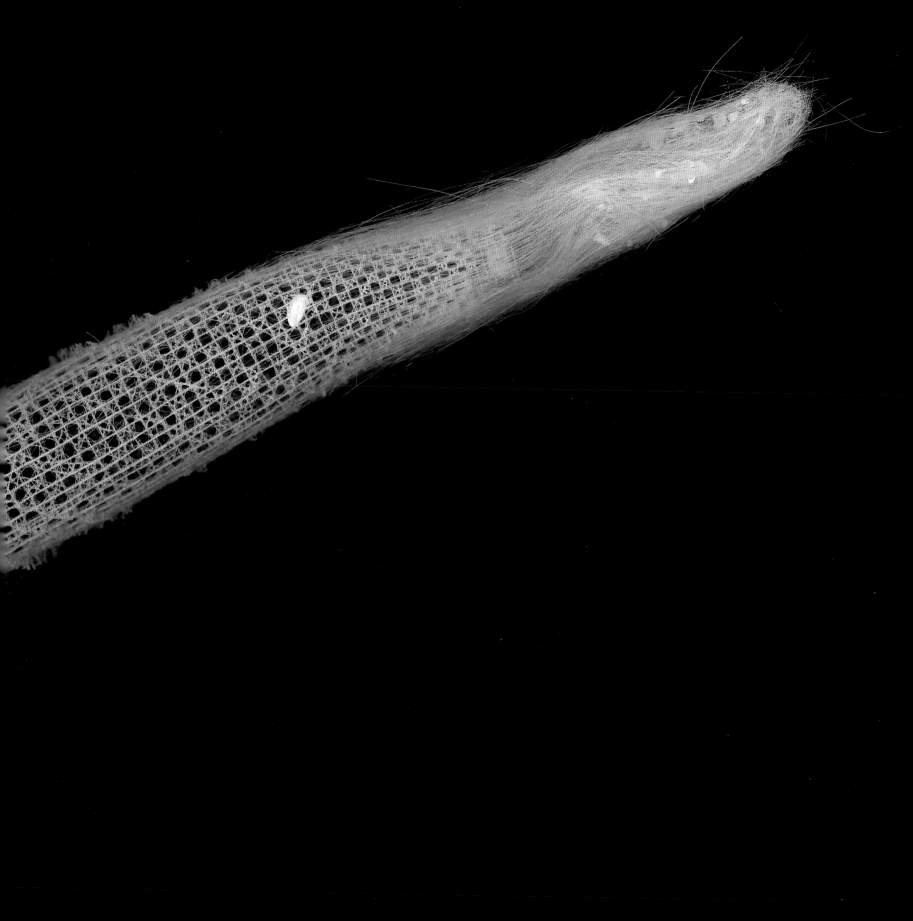

Antibodies

29

THE CUTE LITTLE TWO-YEAR-OLD with the fever—the one doing her bit to enable her virus to achieve its manifest destiny—has succeeded. You have the flu. Now that you are infected, what do you do about it? Before the virus destroys your lungs, and—quite incidentally for the virus, if not for you—kills you?

We have evolved a clever strategy to protect ourselves against infectious two-year-olds. We deploy molecules called antibodies that attach themselves to anything—proteins, cells, viruses—that is "not us." If it is not recognizable as "friend," it is assumed to be "enemy." Antibodies are a little like the family pit bull: loving to the children; hostile to all strangers. Once the antibodies are attached, the stranger is labeled as dangerous, and the adults—cells called macrophages and killer T cells—attend to him. To make sure their grip on the stranger is firm, antibodies come with two "hands."

Are there mistakes? Yes. "Allergies" are this wonderful system getting it wrong; the cells that produce antibodies can mistake bee venom, pollen, proteins in fish soup, or feces from dust mites as evidence of infection by parasites, with unhappy consequences. Autoimmune diseases such as arthritis, lupus, and myasthenia gravis also show the immune system mistaking "friends"—our own tissues—for "enemies"—pathogens.

Scientists often learn by combining bits of information from many sources, as pointillists painted using many dots of color. This image—antibodies spread on a surface and examined by electron microscopy—looks, at first glance, more like the noise on a TV screen after hours than anything else. But look closely: with a little imagination, some of these blobs can be interpreted as Ys—or rings of Ys—a few nanometers in size. These shapes—even seen only fuzzily—confirm an aspect of the structure of antibodies: that they have two "hands" and one "body." It's just a dot of color on the canvas, but it helps to paint the picture.

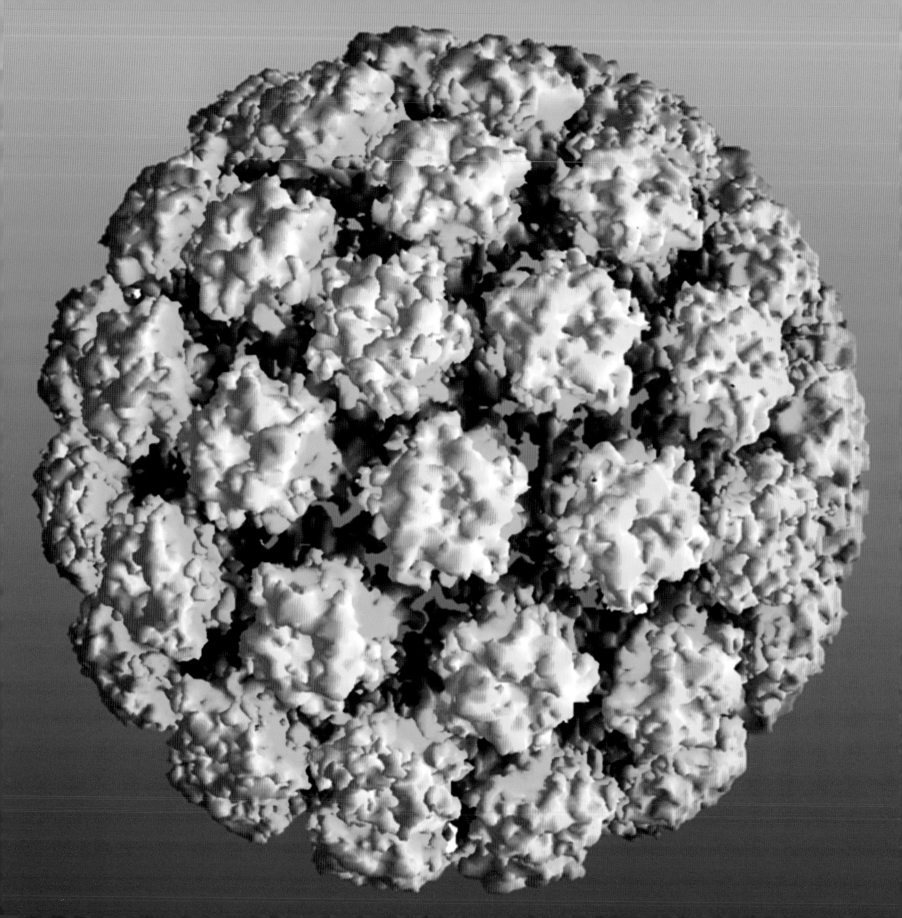

Virus

WE THINK IN WORDS. Without accurate words, we think poorly. Take "alive." We *notice* things that are alive, and know how to describe them. Of course, many more things are *not* alive than alive. Astonishingly, in describing *them*, we fumble. What is a rock? "Not alive," "inanimate," and "lifeless" say what it *isn't*, not what it *is*. "Dead" implies "once alive." We seem to have a blind spot: either something is (or was) alive, or it isn't . . . anything.

If we have only two basic words—"alive" and "dead"—we imply a clear distinction between the two. But is it so simple? Is "alive" or "dead" like "white" or "black"? A sharp line between them? No gradual transitions?

We don't understand how not-alive first became alive. So far as we know, it happened only once on earth, about four billion years ago. Somehow, the mixture of molecules on the prebiotic earth—earth *before* life—taught itself to live. It probably wasn't a single, sharply defined event—*not-alive* to *alive!*— but what it was we just don't know. Now, life always comes from life: cells divide, fish spawn, babies are born.

We understand the transition from alive to not-alive much better, since we, ourselves, die. We also know that death sometimes seems gradual; but when, exactly, does an animal or a cell cease to live? How do we describe it? Perhaps we need a continuum between "alive" and "not-alive"? Alive; partly-alive; dead but with some chemistry still running; *really* dead?

A virus walks the line. Outside the cell, it's just a package of biological molecules: DNA or RNA, and a capsule that contains them. It is no more alive than other small clumps of molecules. When it encounters an attractive cell, it sticks, and forces its DNA inside. This viral DNA enslaves the cell: the molecular machinery the cell normally uses to replicate itself—to make more life—is forced instead to make more virus. So, outside the cell, the virus is dead. Inside the cell, the virus becomes an integral part of something living.

What then is a virus? Not-alive? Potentially alive? Occasionally part-of-something-alive? Not-alive but able to control life? Something else? If we accept that there are things—viruses, desiccated spores, frozen embryos—that are neither clearly alive nor dead, but somewhere in between, the world becomes complicated.

We know we have ethical obligations to living things. But what are our obligations to things that are not fully alive, or are ambiguously not-alive? To think about life and near-life in fresh ways, we need new concepts and new words.

WHY CARE?

Knowing how things work is a great pleasure to some, uninteresting to others. Curiosity is the itch that understanding scratches.

Not everyone itches; but everyone wants drinkable water. "Understanding" makes the water drinkable, and the trains run on time.

It's fascinating to understand how electrons perambulate through the forests of atoms in a silicon crystal. It's satisfying to puzzle out the design of the millions of switches we call the Internet. It's calming to phone Grandma in Ulaanbaatar and wish her Happy Birthday!

Writing with Light

ONE OF THE JOYS OF CHILDHOOD is setting fires. Too bad, but it happens.

There are many ways to start a fire: the simplest is with stolen matches, though wise parents lock matches away to frustrate the demons who periodically hijack their children. Children quickly learn that a lens and sunlight work almost as well as matches. On a bright summer day, a dry leaf can be smoking in seconds, and flaming in a minute. To focus the light of the sun into a brilliant, and *hot*, spot requires only a child's steady hand.

The same strategy forms the intricate traceries of wires and transistors that become microelectronic chips. *Photolithography* is the name of this technique—writing patterns with light. It starts with the brilliant flare of an industrial laser—brighter than the sun, but invisible to our eyes. Moving a focused spot of this light across a film of photosensitive organic matter thinner than the film of a soap bubble draws the patterns that give integrated circuits their shapes and functions.

A faster method of writing patterns shines the light through an opaque stencil onto a polished disk of silicon coated with the photosensitive film, and forms many lines at once. The process is like black and white photography, but with enormously higher resolution. The images so produced become, with manipulations that are probably among the most clever that humankind has ever produced, the nanoscopically structured brains of the devices—cellphone, Blackberry, Wii—that spin the cocoons of digital cotton candy in which we spend much of our lives.

Eleanor Rigby

32

MUSIC DOES SOMETHING WE DON'T begin to understand: it transmutes sound into emotion. The Brahms *Requiem* brings us exaltation; Muzak, boredom; the Doors, desolation.

"Eleanor Rigby" is a song by the Beatles: it generated a sense of isolation and failed opportunity, and reflected, perhaps, the incompatible mixture of hope and resignation that permeated society during the nuclear terrors of the '60s. We all wanted to hear "Eleanor Rigby." Since the Beatles could not sing to everyone, we used machines to sing to us all.

We have invented many ways to replicate music. With learning and practice, we ourselves can sing; with records, magnetic tapes, CDs, iPods, and disk drives we can be sung to. This image magnifies the epitome of an almost forgotten but much beloved form of recording. It shows several tracks of a 33-rpm vinyl recording of "Eleanor Rigby." The delicate needle of the record player rested in the grooves; as the disk turned, the needle followed the wiggles imprinted there. The tiny vibrations of the needle—side to side and up and down—generated voltages in a cleverly responsive crystal; amplification of these voltages provided power to speakers. Our ears transcribed the resulting waves of pressure in the air into waves of pressure in the cochlear fluid, analyzed them by tone, intensity, and duration, and shipped the data to our brain. The brain generated a perception that we call music, and an emotion we call despair.

From the nasal whine of the Beatles, through oscillations in plastic, air, and fluid, to emotion. Remarkable.

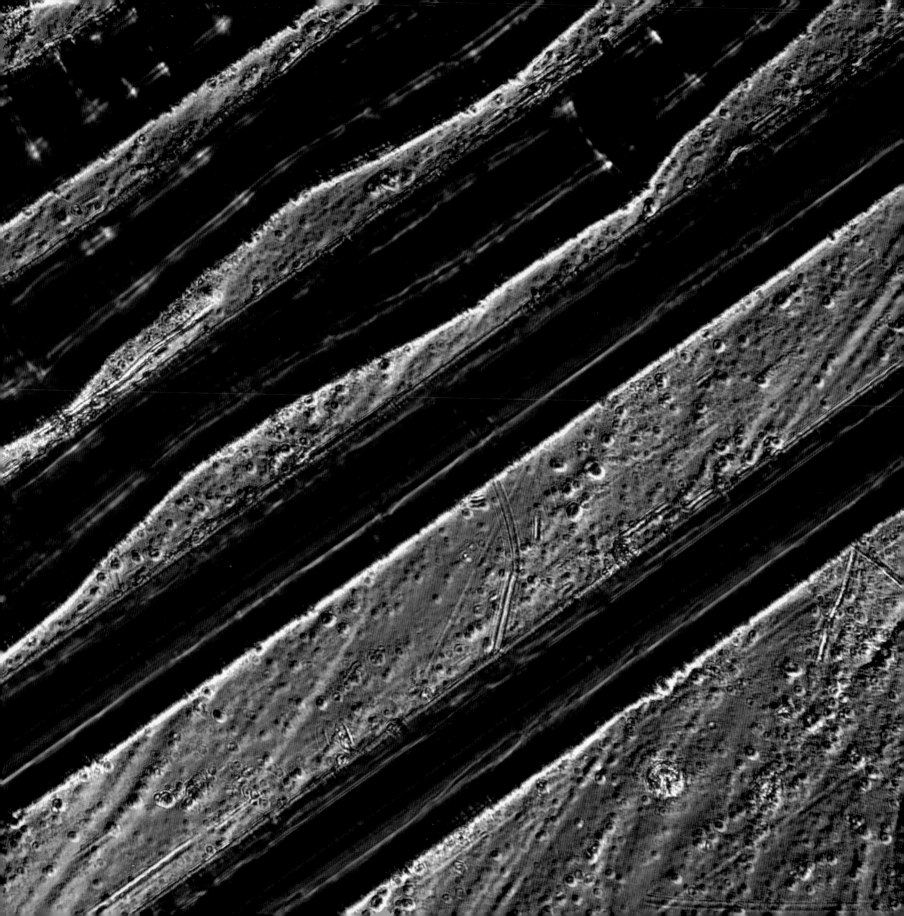

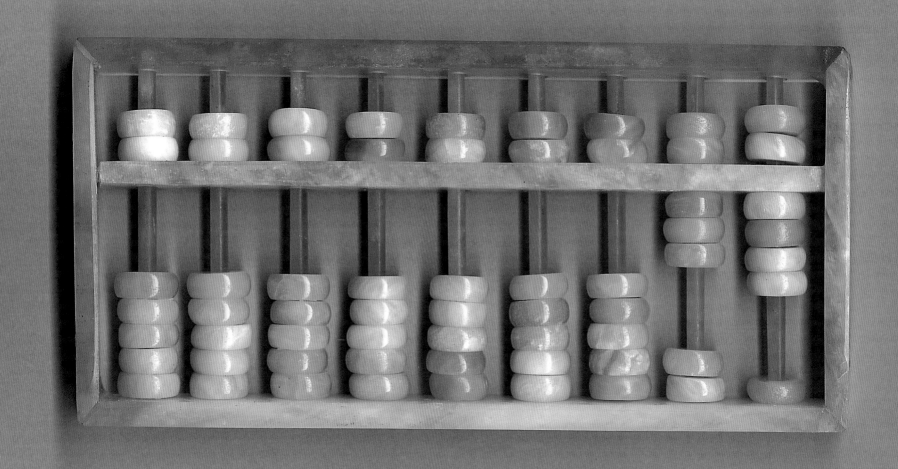

Abacus

IT'S NOT CLEAR WHEN HUMANS began counting. As long as 20,000 years ago, scratches on bones suggest a system of numbers more sophisticated than "1, 2, many . . ." When we needed to know the number of sheep in a herd, or perhaps how many loaves of bread bought one sheep, we began to take counting seriously. With 10 fingers, a number system based on 10 was an obvious choice.

It's easy to lose track with fingers. Also, not everyone's fingers are equally agile, nor does everyone have 10 fingers. We tried many different systems of numbers, and devices, to help in counting: notches on sticks, strings tied together, pebbles in pots. The abacus is so simple that it has survived for millennia. The five beads on a bottom wire count 1 to 5; the two beads on the top wire each stand for 5.

Why not use an equivalent system—one based on the natural arrangement of 10 fingers, or on the abacus—for counting with computers? For one thing, there is nothing natural about 10 fingers; with a slightly different throw of the evolutionary dice, we would have three fingers, an entirely different piano repertoire, and the instinct that "natural" was powers of 3. More importantly, in the same way that it's easy to get confused with lots of fingers, it's easy to confuse a computer with too many kinds of numbers. The least confusion, the least ambiguity, and the easiest checking for errors come when there are only two numbers: 0 and 1—or "binary."

Counting on Two Fingers

34

In counting, almost anything works: raised fingers, pebbles in a pile, knots on a string. We gravitate toward 1, 2, 3, 4, 5, 6, 7, 8, 9, 10 because evolution gave us ten fingers. Computers don't fret about evolution: they do what they are told.

Why is binary best for computers? With only two possibilities, it's difficult to make mistakes. Any system with only two unmistakably different states will do: 0, 1; red, blue; full, empty. The rules of binary addition are also simple: $0 + 0 = 0$; $0 + 1 = 1$; $1 + 0 = 1$; $1 + 1 = 0$ (and carry 1).

These are glasses viewed from above; the red liquid is a good Shiraz. Think of pouring liquids from glass to glass, and you understand how a computer adds. A 0 is an empty glass; a 1 is a filled one. The glasses show the addition of two binary numbers: $001100 + 010110 = 100010$. (On our fingers, this addition would be $12 + 22 = 34$.) A computer, adding these same numbers, would pour electrons from one container (one we call a capacitor) to another. In binary, counting with wine and counting with electrons works equally well.

In their electronic world, computers can be distracted by noise. When they err, we suffer: GPS takes us to a cornfield rather than a restaurant, or the telephone drops a crucial word: "I . . . you!" Noise—the overheard whispers from other electronic conversations; the bursts of static from an occasional cosmic ray or a witless shark gnawing on an undersea cable; the low level of crackle on the line that physics tells us is always there—all cause mistakes. No system is perfect, but binary resists the confusions of noise better than any other system of counting. For computers—which make sharks seem like towering intellects—simplest is best.

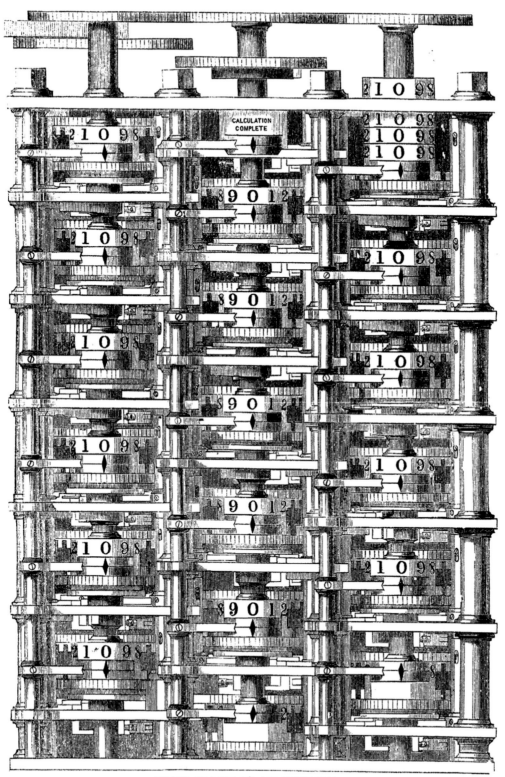

PORTION OF BABBAGE'S DIFFERENCE ENGINE.

Babbage's Computing Engine

TO ADMIRE THIS MACHINE is to admire the cave paintings at Lascaux, plainsong, or the Wright brothers' airplane: it was a beginning. We humans have invented countless machines to manipulate objects. This machine—designed by the Englishman Charles Babbage in 1849—was invented to manipulate numbers. It would have been the first programmable computer.

Babbage's engine has almost nothing in common with electronic computers, but it wove the first thread in the filigree we call the world-wide web. Babbage was obsessed with measurement and numbers. Although he would have recognized the word "information," he could not have imagined a planetary-scale lacework of optical fiber and computers. Still, he had the right idea: his engine was intended to solve arbitrary problems in arithmetic, and thus to lift the burden of addition and subtraction from the stooped shoulders of distractible, error-prone humans and place it on the broad shoulders of machines. Babbage's engine had very broad shoulders indeed. It was never completed, but had it been, it would have weighed several tons.

The difference between Babbage's engine—a large, mechanical adding machine—and the computing engines (microprocessors) everywhere, even in cellphones, is the difference between a dripping faucet and Niagara Falls. Part of the difference is the size of the components. Babbage used machined wheels and cogs centimeters across; computer chips use wires less than 40 nanometers wide—a width spanned by 100 atoms of gold. Speed is even more important: microprocessors compute perhaps a trillion times more rapidly than the machines Babbage imagined.

Computers as Waterworks

WHAT, REALLY, IS A COMPUTER? Think of a municipal water supply. It's a system of pipes and valves that pumps water from reservoir to kitchen. The pipes are hollow iron tubes, and the valves are . . . well . . . valves. A computer is not so different. It's a system of pipes and valves that pumps streams of electrons rather than streams of water from place to place. Of course, nothing is hollow: the pipes and valves for electrons are made of solid metal and silicon (usually with a *soupçon* of added boron or phosphorus). Still, the electrons flow through silicon more smoothly than water through a cast-iron pipe.

But it's not where the electrons *go* that counts, it's how they *get* there, and how valves-for-electrons (called transistors) control their flow. With proper valving, the fluid—the electrons—can do binary arithmetic. Because the transistors—the valves—open and close quickly, this arithmetic-carried-out-by-pumping-electrons-between-containers is extraordinarily rapid (currently, about a thousand billion additions per second).

Binary numbers can also be used to represent almost anything else you like—letters, colors, pitch, intensity of sound—by assigning identifying labels. The assignments are arbitrary—the letter *a* has the binary name 01000001, and the punctuation mark *!* is 00100001—but are universally readable, since everyone subscribes to the same conventions. From these assignments grow word-processing programs, text messaging, and Blackberry images.

And that's all there is: selling a load of fish by cellphone in Thailand, writing a besotted love letter on a laptop in Indianapolis, downloading Beethoven's Ninth in Tierra del Fuego, landing a 747 after a long flight from Mumbai—it's all just moving and recognizing and adding incomprehensibly large numbers of 1s and 0s incomprehensibly rapidly.

Technological reductionism does take some of the romance out of writing love letters in Indianapolis. Maybe we should stick to longhand for some things.

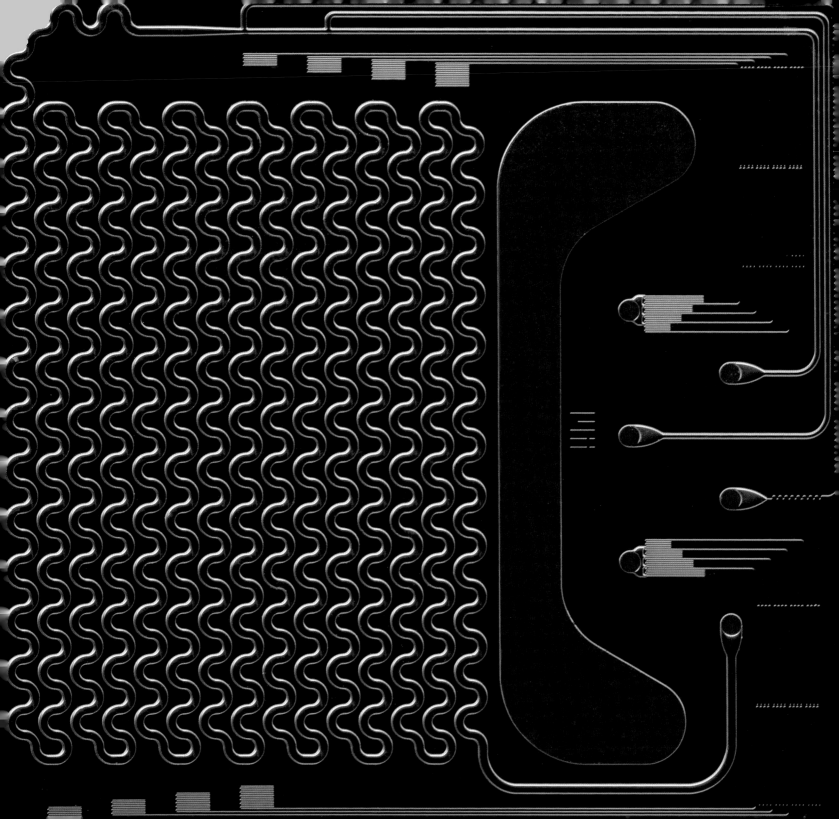

Microreactor

MAKING ALMOST ANYTHING can be dangerous. An automobile seems solid enough, but it comes from blazing cauldrons of liquid steel, stamping presses able to squash us into sticky films in a millisecond, and laser welders that would not notice if they cut us in half. Had he understood the indifference of manufacturing technology to human comfort and safety, Dante could only have been inspired. Still, managed by experts, industrial processes do operate safely, or at least safely enough.

Some things are intrinsically safe: it is difficult to come to harm with mattresses or marshmallows. Others pose little risk in the hands of experts but are dangerous to amateurs: kitchen matches are safe in the hands of a cook, but not in those of her six-year-old son. Some things are never entirely without danger: objects at high temperatures, toxic chemicals, explosives. How should we handle them?

One approach to dealing with the necessary and incidentally toxic chemicals occasionally used in technology is to make them only in small quantities, and consume them as rapidly as they are produced. That strategy minimizes damage if something goes awry. This device is a microreactor—a set of channels on a chip designed to carry out dangerous chemistry quickly, continuously, and always in very small quantities.

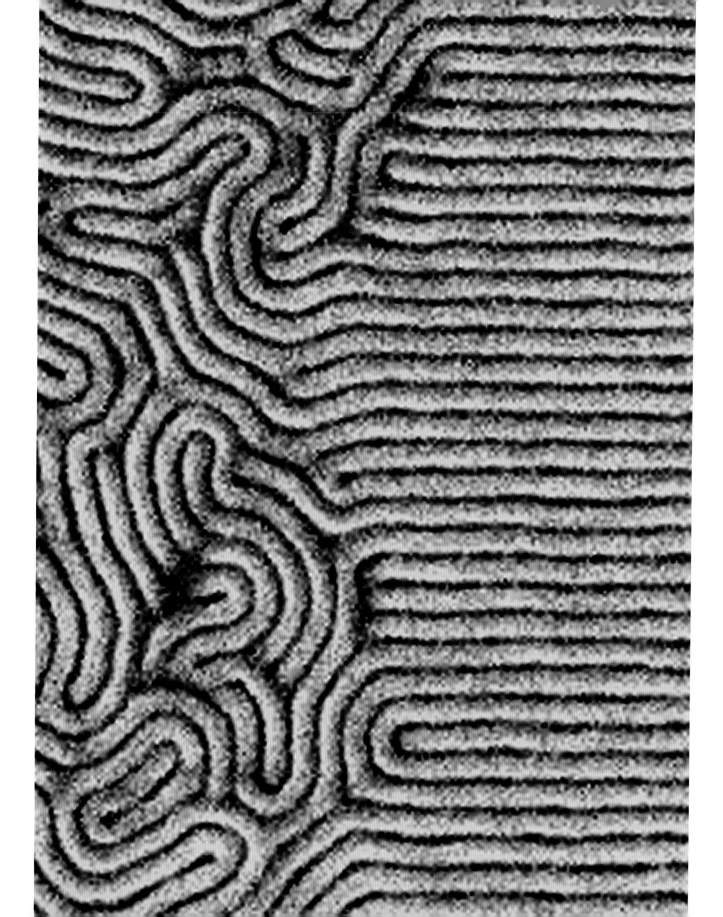

Templating

SUPPOSE YOU NEED TO ASSEMBLE MOLECULES or nanoscale colloids into a regular assembly—a crystal, say, or some part of an electronic device. How would you do it? How could you ever develop fingers small enough to put such tiny things into their place? You couldn't. The best you could do is to *encourage* them to assemble spontaneously as you would like them to, and to give them instructions—a template or pattern they could follow.

Imagine a large group of people, and the chairs on the next page, and you'll get the idea. The chairs are ordered; they are regularly spaced; they point in one direction. They invite, command, orient a milling crowd—to sit down for a wedding, a graduation, a funeral. As everyone takes a seat, the crowd assembles itself into a pattern set by the template.

"Chairs" for molecules? What would they be? We don't know the best answer and are still testing strategies. The face of a growing crystal is a familiar template for nanoscale assembly. The molecules exposed at the face form an ordered array: new molecules joining the crystal sit on top of the ones already in place, so the crystal grows, layer by identical layer.

The image opposite shows rows of molecules (*large* molecules, called polymers) on a surface. These molecules have two dissimilar ends, and the "like" ends cluster together into long rows a few tens of nanometers wide. In half the image, the molecules are guided into a regular pattern of parallel rows by a template of parallel stripes written on the surface. In the other half, there is no template, and the rows of molecules wander, unguided.

Sometimes a crude template works surprisingly well. The operation of liquid crystal displays (the displays on most cell phones and computers) requires pencil-shaped molecules to stack in a fashion that is *partially* ordered (less-ordered than a crystal, more ordered than a liquid; hence, "liquid crystal"). Gentle mechanical rubbing of the surface of the display in contact with the liquid crystal seems to guide this ordering. It probably produces microscopic scratches, but we don't know exactly how the process works. It might be similar to asking a crowd to stand in a tilled field: the parallel furrows would provide a pattern of sorts, but it would not produce the order of folding chairs.

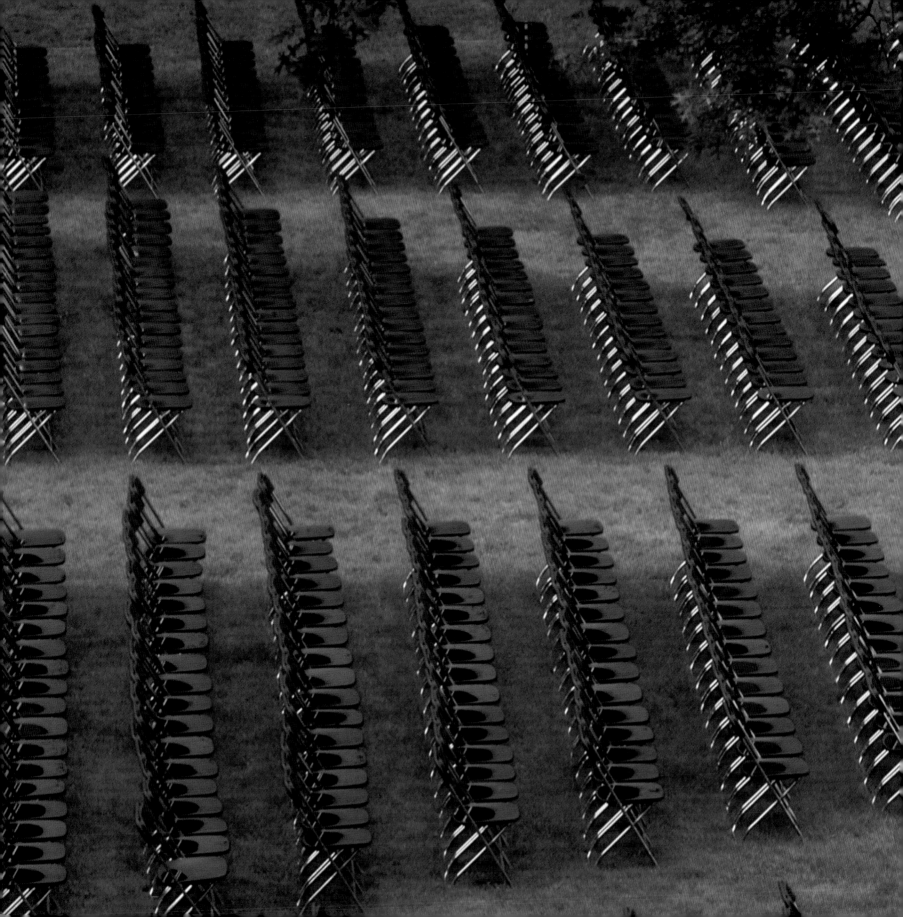

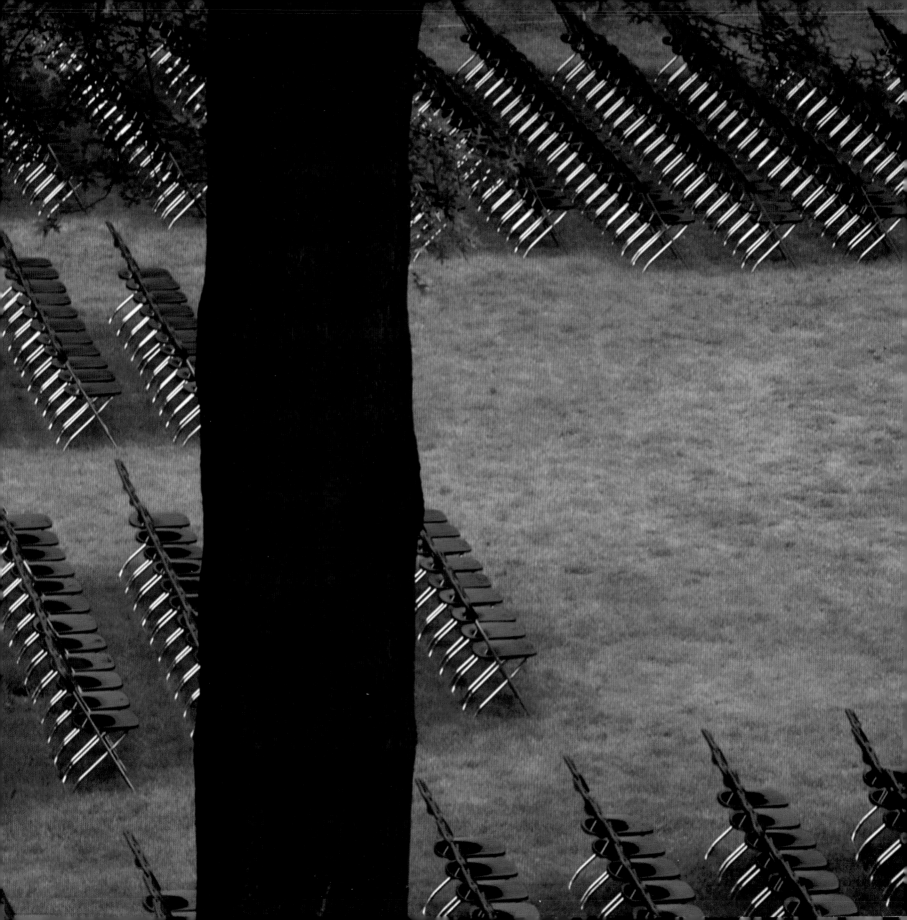

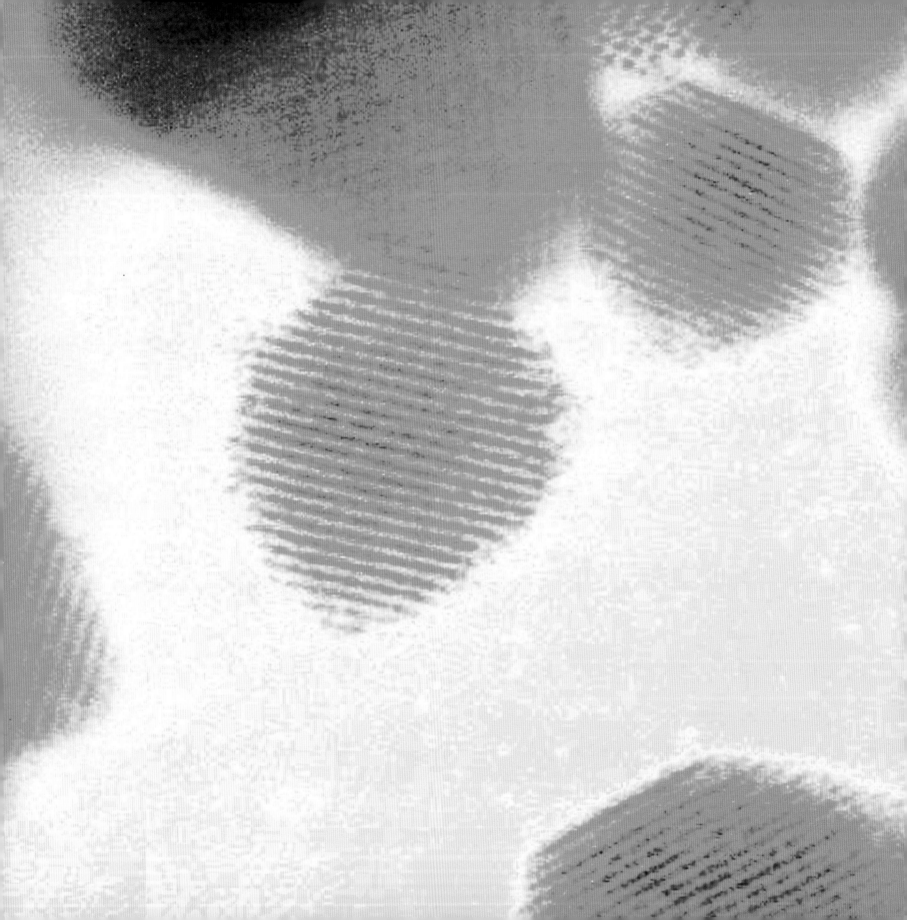

Catalyst Particles

MILK, FLOUR, SUGAR, CARROTS—in the hands of a chef, groceries become a feast.

A "catalyst" is something that causes a transformation but is not changed in the process. A chef transforms ordinary ingredients into a sensory delight; but after the cooking is done and the meal is exclaimed over, she is still a chef, and ready to cook again.

This image shows nanoscale particles of metal. The lines, separated by about 1 nanometer, are layers of atoms (or, rather, the *shadows* of these layers, cast in the light of a *very* expensive "flashlight" that focuses a beam of electrons, rather than light, into an illuminated point a few nanometers in diameter). This kind of particle (a mixture of platinum and cobalt atoms) is designed to make fuel cells extract electricity more efficiently from hydrogen and oxygen. Similar particles (in multitudes, supported on particles of clay and ceramic) transform crude oil into gasoline and jet fuel, while others process the molecules used to make drugs. After the chemistry is over and the products have been removed, the catalyst is still there, unchanged.

A good catalyst, like a good cook, starts with inexpensive ingredients and makes something valuable. A bad one, like a bad cook, makes a pig's breakfast.

Christmas-Tree Mixer

SMALL VOLUMES OF LIQUID can be important. Only a drop of blood is available from a finger prick, and only a drop of urine from a newborn human or an adult mouse. If you have a few rare cells, you must keep them in small volumes of liquid just to avoid losing them. Dangerous chemicals are always best used in small quantities. There are many reasons to be interested in small volumes.

Microfluidic systems make it easy to handle very small volumes of liquid, but mixing is a problem. To mix two liquids—even viscous ones—in large quantities, you use a motor, and attach it to a propeller, or a screw, or rollers: think egg beater or dough mixer. Microfluidic systems do not accommodate motor-driven mixers: it's difficult to attach motors to hair-sized channels, or to insert propellers into them. An alternative is to force the liquids to flow as thin, adjacent streams, and then let the diffusion of molecules between streams do the mixing.

Mixing is also useful in forming gradients. A *gradient* is a continuous change in something with position. For example, the annoyance caused by the neighbor's car alarm going off decreases with distance: up close, it's unendurable; the farther away you get, the less awful it is. This device is a microfluidic mixer that makes gradients in biochemicals. Two fluids—red and blue—flow from the top into a network of 100-micron-scale channels. They converge, mix, divide, reconverge, remix, and redivide, forming a smooth gradient from red to purple to blue at the bottom. This kind of mixer—using biological signaling molecules rather than dyes—allows cell biologists to ask a cell living in the exit channel a question: Do you like a higher concentration of what I'm offering you, or a lower one? The answer to that question helps biologists understand how cells know what organ to form during embryonic growth, and how they find an infected cut on a leg.

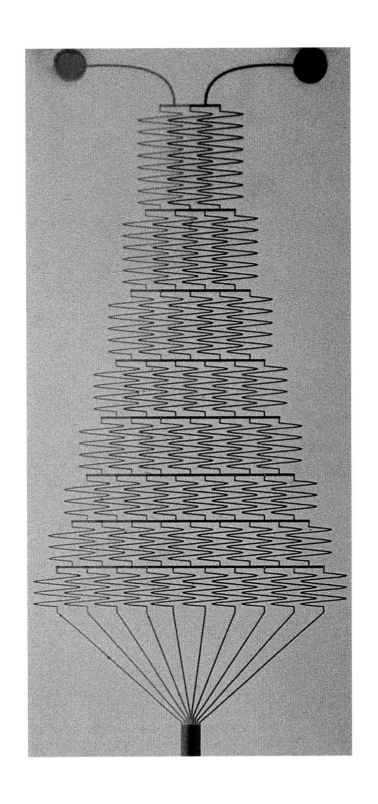

Self-Assembly

WE FILL THE WORLD WITH MACHINES that do for us what we can't do for ourselves: airplanes let us fly; cell phones let us gossip when we are beyond whispering range; Wii makes it unnecessary to find a tennis partner. We machine, refine, cast, drill, weld, bolt, stamp, mold, glue, and implant. We build robots—themselves complex machines—to help us.

We are effective but sometimes inelegant in making things. Is there another way? We *know* there is: life provides the most astonishing examples. Cells, and organisms comprising many cells, assemble themselves. We do not fabricate a baby, molecule by molecule. Her pieces—molecules, cells, tissues, organs—put themselves together in the proper order: they *self-assemble,* rather than requiring assembly by external devices or by people.

Many forms of self-assembly are familiar, if often unnoticed. The disordered molecules of liquid water order themselves into crystalline ice; ice spontaneously grows into intricately shaped snowflakes. Salt forms beautiful polyhedra when sea-water evaporates slowly. Sand pushed by the wind forms dunes. The tiny bubbles on the surface of champagne organize themselves into clusters before they burst and their spray tickles your nose.

This picture shows millimeter-sized glass spheres resting in two dishes with slightly concave bottoms. With a few taps on the side of the dish, they "crystallize" into a pleasingly regular array. We can admire, but we don't have to be involved. It's easier that way.

Will we ever be able to put the parts of a computer into a bucket, shake gently, and see a computer spontaneously emerge? Not soon; but even small steps in the direction of self-assembly could save enormous effort by humans and machines.

Synthetic Nose

WE AND DOGS—OUR SPECIES' ANCIENT COMPANIONS—sense the world in complementary ways. We see; they smell. Perhaps that's why we've gotten along: we hunt well together, and we protect and amuse one another.

Protection! Our lives depend on it. Dogs could smell the lion we could not see. And although lions are now not an everyday problem, we rely on dogs to discriminate odors—molecules drifting in the air—where we see nothing. They sense strangers at night; fires while we sleep; drugs hidden in suitcases; the tracks of lost children. They can also detect nitrated organic compounds wafting from explosives.

Although dogs are unparalleled in their combination of sophisticated nose and substantial intelligence—and *very* skilled at detecting bombs—we would prefer to save them for safer jobs. And, of course, dogs can be fallible at a job where a mistake can be fatal: they have their moods, exhaustions, and periods of ennui.

To relieve dogs of some of the burdens and hazards of being our "noses," we are trying to mimic their discriminating powers of smell. This sequence of images shows the response of an "artificial nose" to a puff of odor. Each spot is a dot of polymer—an organic material we normally encounter in sandwich wrap, disposable coffee cups, and glue—containing a dye that gives off visible light when illuminated with ultraviolet light. The emitted color is very sensitive to the presence of other molecules dissolved in the polymer. When an odor in air drifts across the assembly of spots, the odor molecules dissolve in the polymers, and their colors shift; when the molecules evaporate, the colors shift back. These patterns of drifting colors can sometimes answer the crucial question: "Explosive or sausage?"

Such systems are primitive compared to a dog's nose, but for detection of a land mine, primitive may be enough. And it might allow us, for once, to honor our obligation to protect our gifted friends.

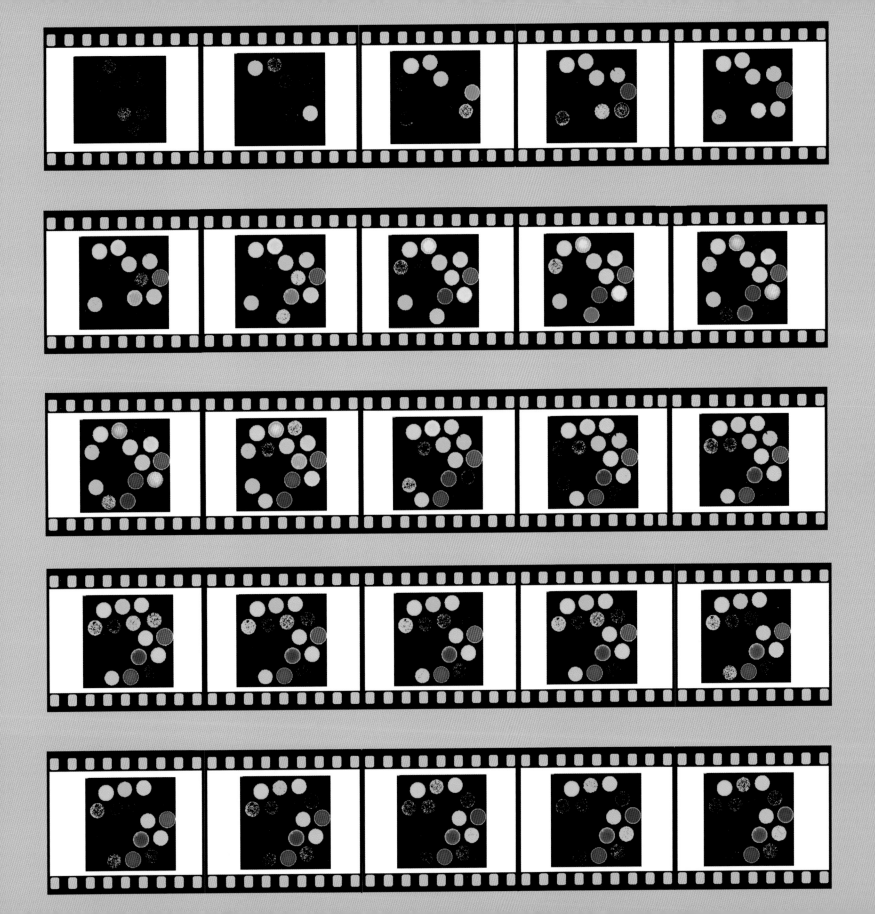

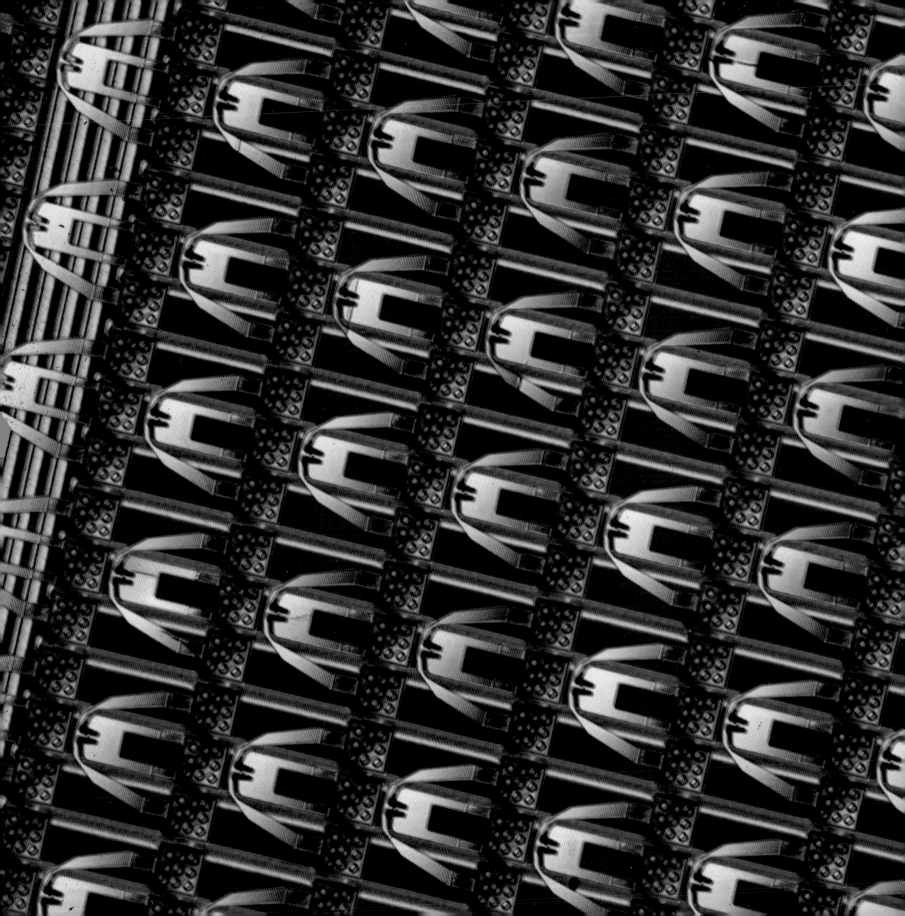

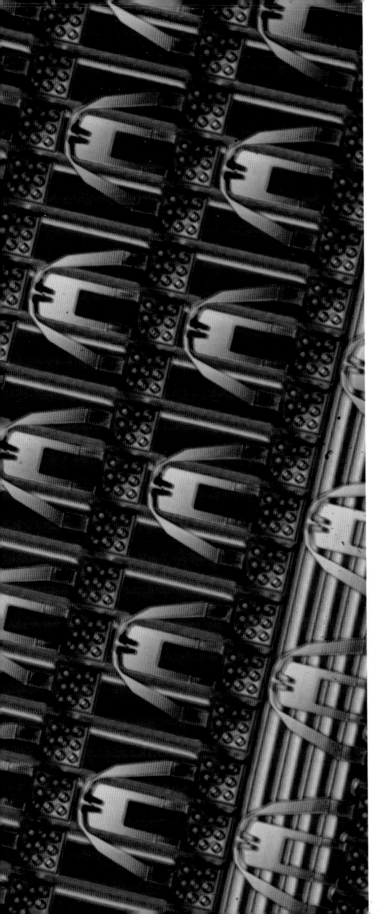

Millipede

"INFORMATION" IN OUR digital world is not stories from the mouths of wise, warm grandmothers, but cool strings of 1s and 0s streaming from place to place, or resting in storage.

Because we use bits (*binary digits*) in enormous numbers, we must be able to read them quickly, and stow them in the smallest possible space. In conventional microelectronic devices, bits are either small regions of doped silicon engineered to hold electrons, or pits pressed into the surfaces of plastic disks and designed to be read with lasers. One new approach to computer memory with high densities would also record information as pits, but smaller ones. But how to read them?

A warm, scanning probe microscope tip would provide one way. If the tip—very similar to the tip of an atomic force microscope—is close to a flat part of the surface spinning rapidly beneath it, it loses heat to it; if it is above a pit—that is, momentarily further from the surface—it loses heat slightly more slowly. The pattern of tiny but very rapid changes in temperature of the tip as the disk spins beneath it provides a record of the pits.

One tip cannot read information rapidly enough to be useful. A thousand tips can, if they read the disk at the same time. The millipede, the device shown here, is a step in this direction: rather than the thousand feet of its namesake, this device has a thousand fingers—a thousand separate tips—and can read a thousand patterns of pits at once.

44

For centuries, we've entrusted our memories, our records, our musings, our imaginings to books. Many centuries, many people, many memories. That's a lot of books. Too many to schlep around; too many to search for the one essential fact; too many to mine for understanding or insight or wisdom, or for entertainment and escape and flights to other worlds.

The Book (as booklovers ironically refer to the object fabricated in paper and ink) now also competes with the world-wide web. The web makes all data—details of everything, imaginative triumphs of language and thought, facts, factoids, falsehoods, drivel—democratically available to anyone.

And where does this leave The Book? The answer is: in limbo. Books have advantages. Their printed words last longer than words held in the magnetic cobwebs of computer memories. They don't use electricity. And people who have lived with books like their heft, smell, and feel, and the fact that you can slip them under mugs of hot coffee to avoid damaging the table.

The electronic book—the e-book—is a shotgun wedding of the aristocratic book and the vulgar web. The electronics of the e-book are straightforward; the display is the difficult part. The "page" of this e-book is a sheet of plastic covered with many tiny electrodes. The sheet includes droplets of oil containing a mixture of black and white nanoparticles. When an electrode has one charge, the black particles go to the back of the sheet and white light reflects from the front; when that electrode has the opposite charge, the color changes from white to black. Simple electronics stores the original text of the book and converts images of its pages into patterns of charge on electrodes, both using very little power.

The e-book may be the salvation of writing, or the death of it, or it may be an evolutionary eddy—like the platypus—in the co-evolution of humans and their stories. It is as convenient as the book—maybe more convenient. It needs batteries, but what doesn't now? It doesn't quite look like a book, but it holds well over a thousand complete books, and weighs almost nothing. It doesn't smell like a book, and turning a page is a different experience, but for people who have never been hooked on the smell of books, or the whisper of a turning page, perhaps neither counts as a great loss.

"Call me Ishmael" is the opening line from a beloved nineteenth-century paper book. Three letters are replicated here on the plastic page of a twenty-first century e-book.

Lateral-Flow Assay as Crystal Ball

AN OFT-REPEATED FAMILY DRAMA:

The woman, not quite as young as she once was, buys a pregnancy test—a strip of paper printed invisibly with small patterns of molecules and encased in a plastic holder—urinates on the wick at the end of the plastic casing, and gazes on her future. The urine wicks its way along the paper like coffee across a napkin. If the urine contains molecules of hCG—human chorionic gonadotropin (a hormone that appears shortly after pregnancy begins)—these molecules attach to red nanoparticles released by the paper, and the two move together in the fluid to another region where they are drawn down in a line by a second molecule printed in the paper. One line means only "the test is working"; two lines mean "you're pregnant."

It's like a game: If your name is Sue, pick up a red beach ball, and go stand over there so we can see who you are. Except in this game, the name is hCG, not Sue, and it is not a game at all.

One thin red line marks the difference between pregnant and not-pregnant, and tells whether Fate will favor the woman with a child, or has again ignored her, at least this time around.

Testing Drugs in Cells

46

WE HAVE A TOUCHING BELIEF THAT with enough magic we will live almost forever. Enough drugs, enough exercise, enough chickens tied in forests, and age will scuttle away. Exercise *does* help, but it's tiring. What about drugs?

Drugs are complicated. Some work, some don't; some work sometimes, in some people, with some illnesses. All have side effects. Developing a new drug is horrendously difficult: somewhere among the millions of kinds of molecules in you—the patient—a drug must locate and stick to just a specific few, and divert them from whatever mischief they are causing.

Drugs are molecules that do good, while doing as little harm as possible. They must also be profitable. (For the time being, our society has decided that "health" is a profit opportunity, not a social obligation.) Drug developers identify candidate molecules and audition them first in animals—mice, rats, hamsters, dogs. Successful auditionees are introduced into humans cautiously, in the highly regulated, slow, and expensive process known as "clinical trials." Most fail. The central technical problem is that humans are not—however similar they might in some ways seem—large, furless mice. Although different species of mammals have similarities in metabolism, there are also critical differences, and discarded molecules that cure disease in mice, but not in people, litter the laboratories of pharmaceutical companies.

How should one test molecules for effectiveness and safety in humans, if testing is almost prohibitively slow, expensive, and ethically and legally constrained? Testing in human *cells*—available from tissue removed in operations, or separated from blood—offers one new approach. True, human cells are not intact humans, and the difference between a cell and an organism is large. But human cells contain the entire human genome and have the essential features of human biochemistry.

There are many, many ways of looking at a cell. Optical microscopy generated this image showing internal structure, painted with differently colored dyes. A cell biologist, looking at this structure, can gauge a cell's *joie de vivre*, and infer how it responded after tasting a bit of a molecule whose creators aspire that it grow up to be a drug.

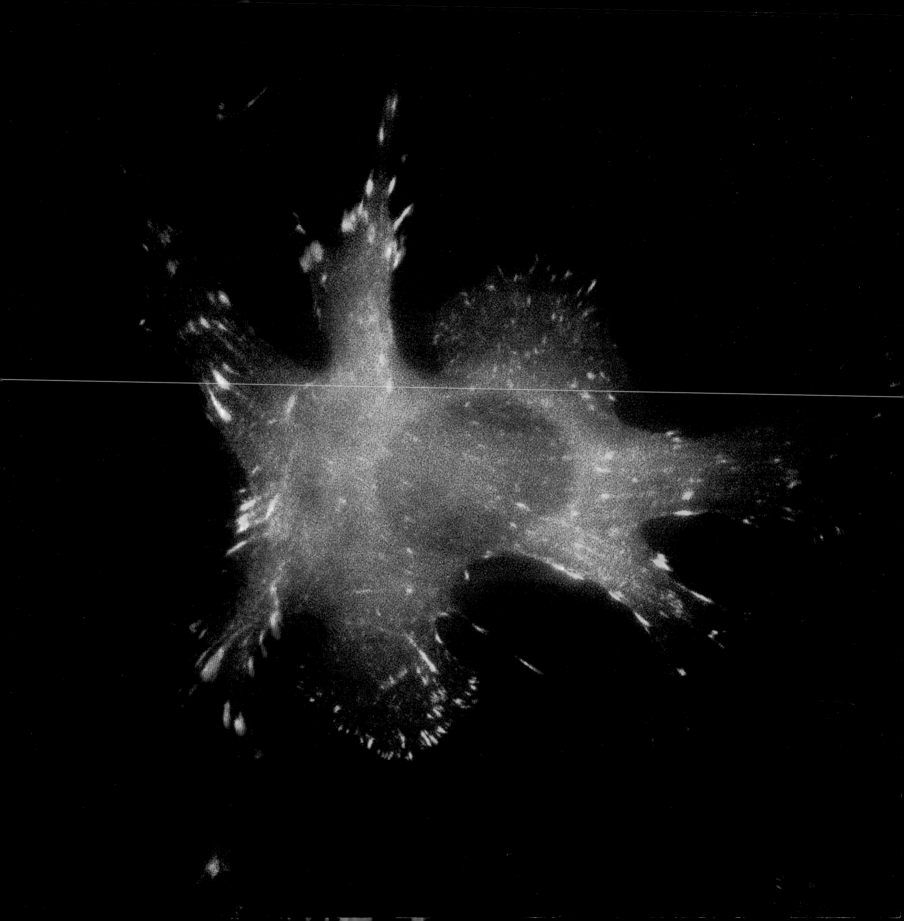

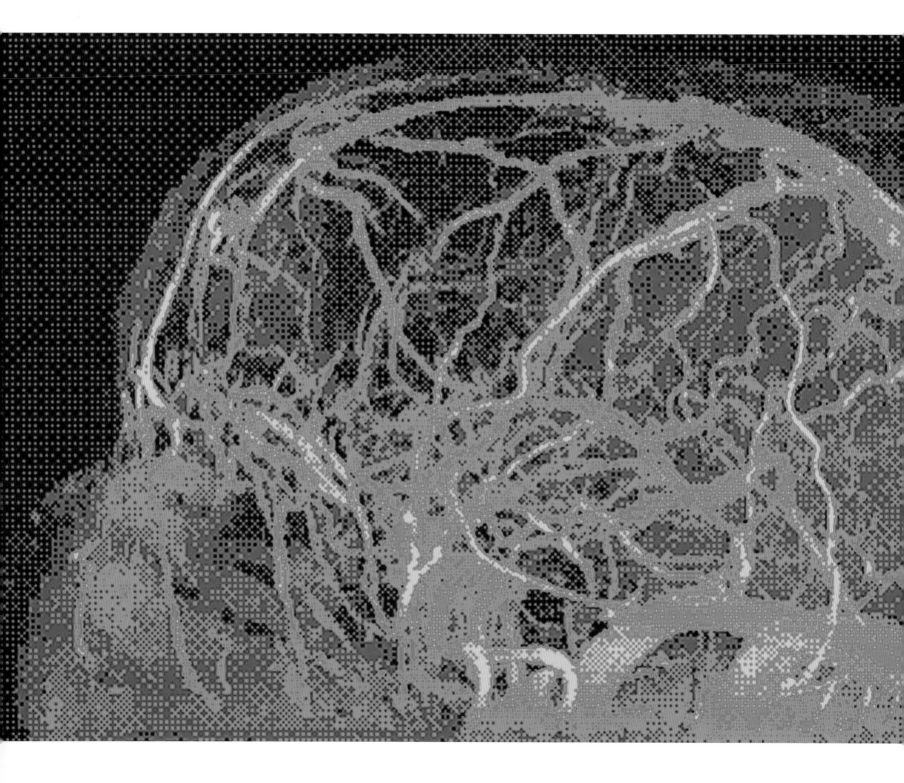

Cooling the Fevered Brain

BRAINS PROCESS INFORMATION; so do computers. Beyond that similarity, the two are mostly different. Brains are what computer geeks disparagingly call "wetware": tissue, blood, and generally messy biological stuff. Computers are "hardware": silicon, ceramics, and metal. Brains store information in concentrations of ions and, in ways we only foggily guess, in proteins and connections between cells; computers store information in electrons and magnetic fields using rules we understand completely. Brains cleverly recognize patterns; computers rapidly add numbers. Brains make it possible to fall in love over dinner; computers let our credit cards pay for dinner.

Brains are liquid-fed and liquid-cooled; the liquid is, of course, blood. A thinking brain heats up. If its temperature rises only a few degrees, it begins to stutter; a few degrees more and it turns to scrambled egg. A network of blood vessels and flowing blood supplies it with the sugar and oxygen it needs to function, protects it from overheating, and removes the waste products of its metabolism.

Magnetic resonance imaging (MRI) can trace the network of blood vessels in the brain; adding nanoparticles of iron oxide to the blood sharpens the images. This network of pipes is riveting to those curious about how the brain thinks, and sometimes helpful to those who try to repair it when it breaks down.

One way to search for an aneurysm or a tumor is to use MRI to look for characteristic irregularities in the vasculature of the brain. In the future, it may also betray whether a brain (or the person it constructs) is lying or telling the truth. Fortunately, watching a brain fabricate a romantic compliment over dinner is still impossible.

A CHEETAH IN THE UNDERBRUSH?

We startle easily. A mildly surprising beginning—a sound out of place, a shadow where none should be, too many tics from a Geiger counter—can have a starkly lethal end.

"Unexpected" can be good or bad. We humans assume "bad," and with excellent reason. "Unexpected and good" we can adapt to at our leisure in the future; "unexpected and bad" can leave us with*out* a future.

Darwin would say it's smart to be conservative when facing something new.

Phantoms

EARLY ON, OUR SPECIES REALIZED that we held a weak hand in the card game of evolution. If we met a cheetah, the cheetah won. If we had a rock or a sharp stick, the cheetah still won. Darwin would have bet on cheetahs.

For once, Darwin might have bet wrong. We learned, eventually, that by forming groups with many sticks and many rocks, and by exercising our anatomical oddities—a large brain, a larynx that formed the complex sounds of language, an opposed thumb—the odds switched to favor us. Still, the unpleasant experiences of the childhood of our species have tended to stick. Faced with something unfamiliar, we are simultaneously curious and afraid. To remind us to be careful, we construct things that go bump in the night—phantoms, trolls, chain-saw movies.

This field of shimmering light, with unrecognizable shapes inside, could be anything: best to assume it's dangerous! (It is, in fact, a fountain playing over rocks; but no matter.) We treat new technologies in the same way. At the beginning, they are all dangerous: fire, the book, steam engines, genetically engineered bacteria, nanotechnology. But with enough familiarity, we ignore even the truly dangerous ones—nuclear weapons, ubiquitous surveillance, smoking, drinking and driving, the sports channel on TV.

And even after learning how to deal with cheetahs, we might neglect to notice that the stick on the road is a black mamba, or that a 20 percent annualized, risk-free, after-tax return on investment has a funny smell.

Perhaps Darwin would have bet right after all?

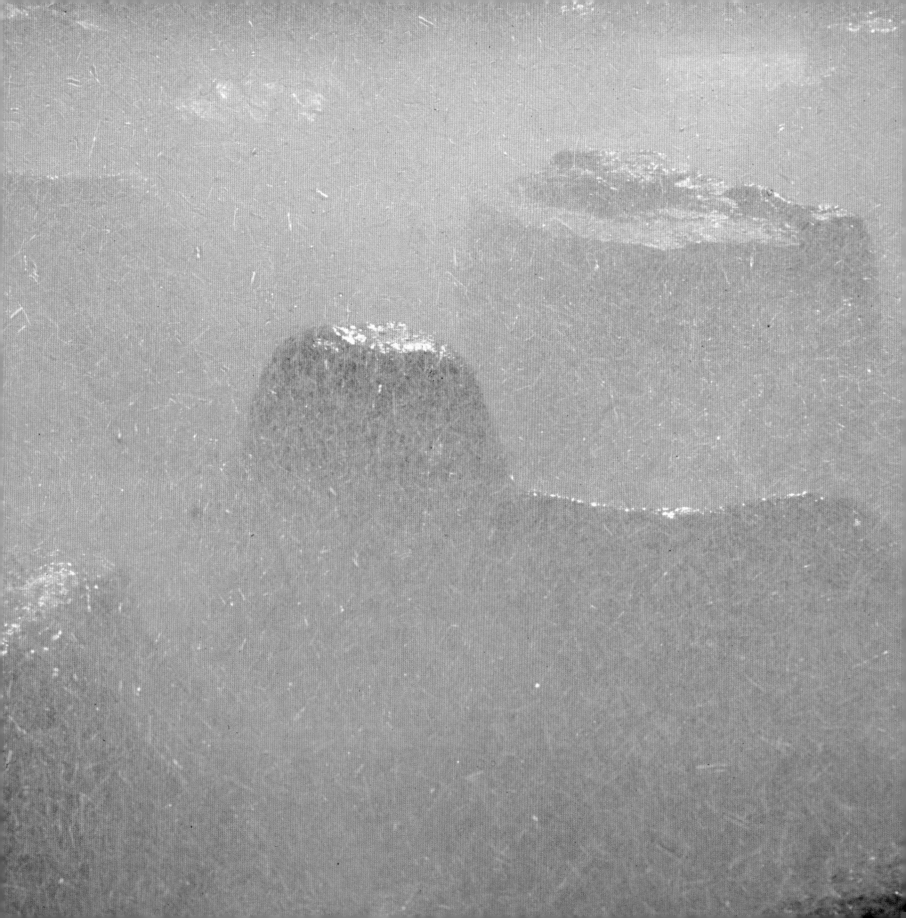

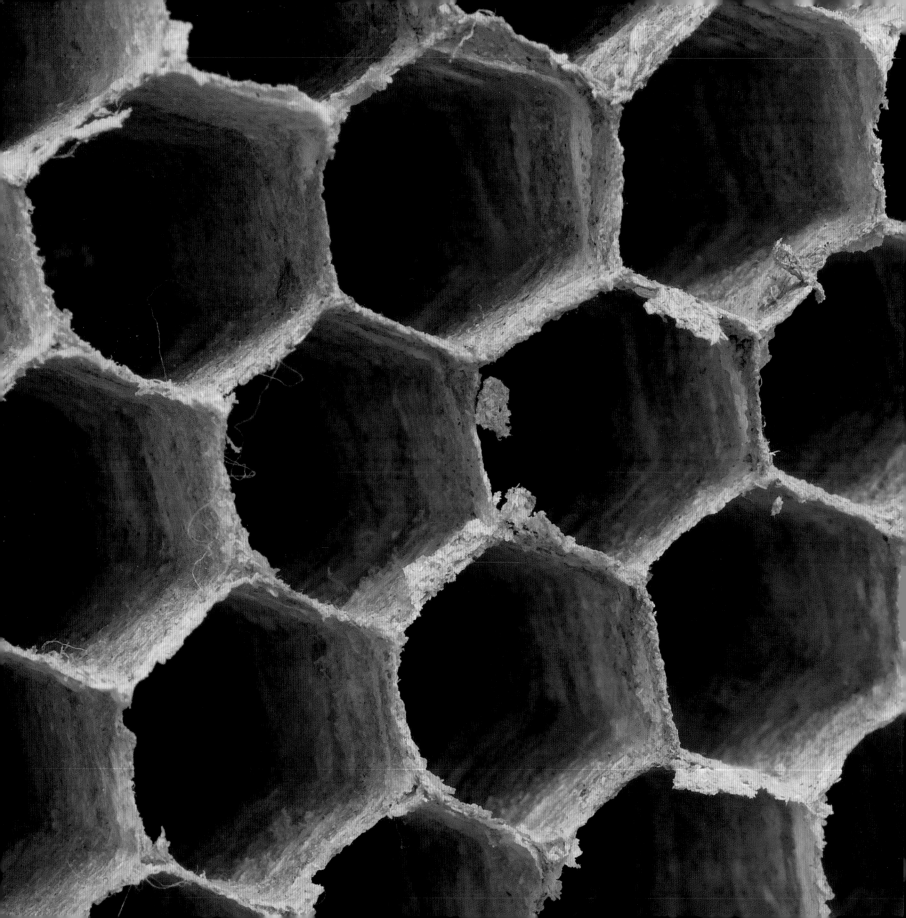

Privacy and the Nest

WHEN WE THINK "WASP," we think "nest." But in fact, most kinds of wasps—especially the more primitive ones—are solitary; only the more advanced have invented the complex social world of the nest. This nest was home for a species of intermediate complexity.

We humans learned in our dawn—perhaps 200,000 years ago—that groups offered safety and company. Our history has been one of ever larger groups—family, tribe, village, city, nation, coalition. Technology is just now allowing us to build a yet larger group: the global village. Back to the beginning, but much, much bigger.

Humans chatter: we love to talk. At first, we shrieked and hooted across the savannah. Later, we walked to the next village to share supper and news. Newspapers, highways, telephones, airplanes, TV—each provided a new way for the village to gossip. Now we have invented the Internet, a new kind of nest for a more complex society. Wasps build their nests of paper; we build ours of optical fiber, computers, and bits.

Gossip is terrific fun, and good for business. It also threatens privacy. If everyone can find out anything about anyone just by asking the Web a few questions, we've gained connection but lost separation. Is the end of privacy also the end of individuality? We hope not, but "six degrees of separation" really works: the combination of computers, humans, and the Internet is startlingly close to being able to answer any question we can ask. And if we all know the same answers to the same questions . . . ?

Do we like this thinning boundary between connection and privacy? Do we have a choice?

Soot and Health

50

SHOULD WE WORRY ABOUT nanoscale things? Is there anything about them that should cause alarm?

The lungs are the swinging door into the body. All small things are . . . well . . . small, and tend to float in air, where we inhale them. If deposited in the lungs, these particles might, perhaps, be eaten by cells, and the smallest—those approaching the size of molecules—might even pass between cells and into the blood.

None of which is new. Our species has always had lungs, and we have always lived in an unseen fog of small particles suspended in the air we breathe—in the smoke from wood fires, in the brisk air of the seaside, in the soot from the back of a diesel bus, in dust everywhere. Air may look transparent, but it is usually laden with particles too small to see.

What about a special toxicity of small particles? Unexpectedly, it is probably not the tiniest particles that are the greatest concern. Real nanoparticles tend not to deposit in the lung: we breathe them in, and we breathe them out again. Somewhat larger particles (a few microns across) stick more efficiently. In any event, we don't yet know the answer to this question. Certainly some particles (chalk, silica, asbestos, coal, cigarette smoke, urban pollution) can injure lungs. But whether there is something special about the smallest particles we breathe remains to be discovered.

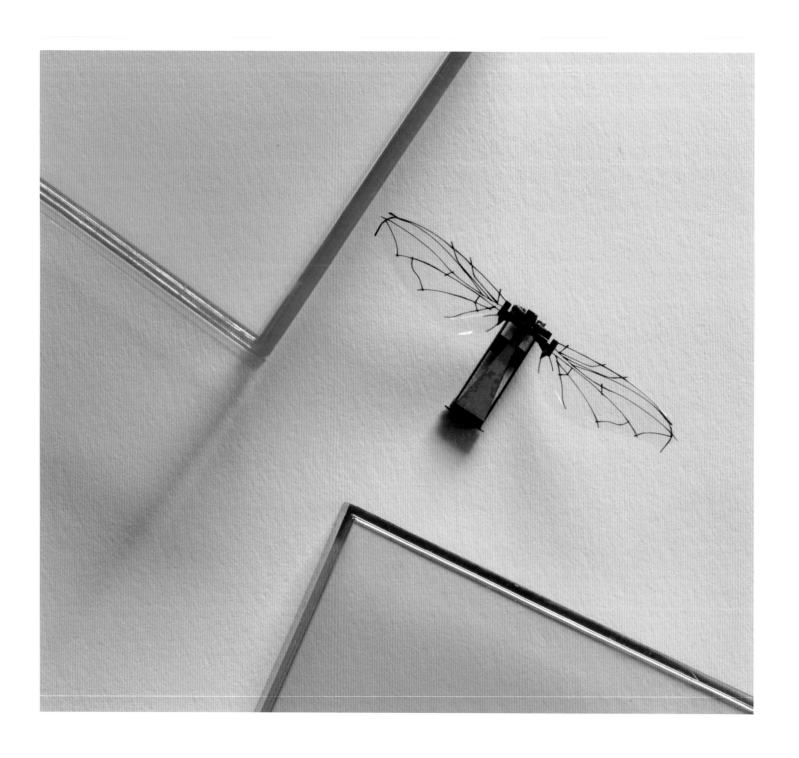

Robots

WHAT IS THE *next big thing*? Information technology has collapsed a world of nations into one global village. Biotechnology has begun to make a difference. Nanotechnology is graduating from diapers. And after that?

One possibility is robots. A music box (next page) is a primitive robot: prongs on a rubber belt moved by a wind-up motor replaced the delicate fingers that played the harpsicord. Today's robots are more sophisticated but still clumsy: lifters and welders. Most are fixed in place. But information technology is now giving robots their freedom to wander. A marriage of threshing machine and global positioning system has produced harvesters that guide themselves across the fields. Airborne drones obey controllers thousands of miles away. The robotic fly (opposite) is an early representative of a new species: a microrobot able to execute the complex wing movements necessary to hover.

A mobile robot must be able to make its own decisions. If, as a robot, you slip on gravel, or encounter a wind shear, you must react instantly; you cannot have a leisurely chat with a distant advisor. Clever designers build reflexes, like those in animals, into their robotic offspring—local circuits that quickly measure, decide, and act.

How will robots evolve? We don't know, but if information technology provides a guide, the answer is "*very* rapidly" and "in ways we cannot anticipate." We *need* robots—to relieve us of unpleasant, boring, or dangerous jobs. But what will they become? Adaptive lawnmowers? The mechanical equivalent of the praying mantis—with lightning reflexes but no personality? Nonliving systems that house a new kind of intelligence? Who knows?

We do know that we followed a similar path in our own evolution. We—or better, the first primitive organisms—survived as collections of reflexes. Over not so many generations, reflexes, intelligence, and Darwinian selection produced Jane Austen and Sun Tzu. How, or if, reflexes aggregate and become intelligence is a subject about which we have many opinions, but understand almost nothing.

Regardless, there will be problems—not now, but sometime. We humans *are* our work, and robots will compete with us for that work. If they are cheaper than we, or more skilled, how will we spend our days?

Fog

"Fog" is "cloud" up close—drifting translucent shadows that blur the ordinary into childhood fairy tales. Fog is a haze of finely divided particles of water or ice suspended around us; when light enters, it refracts at the surfaces of these particles. The blinding white of a cumulus cloud at summer midday is the reflected light that does *not* make it into the cloud's interior. When we are outside, it's "cloud"; inside, it's "fog."

Fog from water is familiar, but any transparent liquid will do. Los Angeles smog is made up of hydrocarbon droplets—residues from gasoline burned in cars and trucks. Appalachian blue haze consists of similar hydrocarbon droplets exhaled by trees. When it comes to fog, "loathe" or "love" is a delicate question of smell and context.

A particularly interesting kind of fog might form if we injected sulfuric acid into the upper reaches of the atmosphere. It would form a thin veil and cast a faint, cooling shadow on the planet below. Technically, veiling a planet in man-made fog would be laborious, but conceptually it is straightforward: enough rockets will do it. And we know the idea works: an Indonesian volcano—Tambora— erupted in 1815 (the largest eruption in the last few thousand years) and coughed enough ash into the atmosphere to shadow and cool the globe. This cooling produced New England's "year without a summer" in 1816.

And why would one want to cool the earth? If the planet becomes too hot—if it seems that global warming is getting out of hand—perhaps we might *need* to cool it? Perhaps we might, and perhaps we also might not. A high-altitude fog might cool the globe, but it might cool it too well. We should be careful when experimenting with the only planet we have.

In Sickness and in Health

FOR MILLENNIA, PLAGUES HAVE BEEN the pruning shears that trimmed unruly growth in population. It's annoying that the gardener is small, mindless, and uncaring—a bacterium or virus.

Bacteria are now easier to re-engineer than watches or windup toys. With guidance, high school students can fit new parts into living cells through genetic engineering. This new competence is invaluable in medicine: when biologists discover proteins that do something helpful in us, they can often construct bacteria to make these proteins in quantity, with the intention (and occasionally the result) of improving our health.

But what about antisocial intent? What about trying to *cause* disease rather than cure it? What about starting with a pathogen—plague or cholera—and making it more resistant to antibiotics, perhaps, or more virulent?

In principle, any skilled geneticist can try. The difficulty is not writing instructions in the DNA, it's knowing what instructions to write. Although we have lived with these ancient enemies for as long as we have been a species, we still barely know what "disease" is, much less how to engineer new features into it. Disease is more complicated than just a few toxic proteins produced by a bacterium; it's a tango that hosts and pathogens dance together. *Their* toxins, *our* antibodies; *their* attachment factors; *our* cell-surface molecules.

So we are protected—to a degree—by our current ignorance of the clockwork of disease. Also by uncertainty about what a really new pathogen might do. Still, genetic modification of pathogens—nanoengineering applied in biology—is something to watch very, very carefully. People with a grudge can still be competent.

But, sadly, nothing new is really needed to cause harm. The old standbys—anthrax, smallpox, tularemia, plague—are more than good enough, given the right opportunity, and without genetic "improvement," to cause endless misery.

WHALE OR HERRING?

Is nano a change in the world-as-we-know-it, or a passing trifle?

Our forebears, when they set out to make their fortunes on the briny deep, had a choice: try to catch a very occasional whale, or seine for herring. Which is nanotechnology? "Whale," and change-the-world, or "herring," and reliable-for-dinner?

We don't yet know.

The Internet

PHYSICALLY, THE WORLD-WIDE WEB—the Internet—is a network of information processors, connected by antennas and optical fibers. It is perhaps the most ambitious project we have started as a species. It is the largest thing we have ever built, and we have assembled it from transistors—the smallest things we know how to make (four billion can fit on a postage stamp). It is a chrysalis we are forming around the planet. Or perhaps it is forming itself. We suspect that something new will emerge from it, but we don't yet know what.

Functionally, the Internet allows information processors to exchange tsunamis of bits, most incarnated as pulses of light and electrical current and bursts of microwave transmissions. The hubbub! A part of the world—the richest part—already lives in an atmosphere that is a froth of air and bits. The poorer parts are catching up: first water, food, and electricity, then cellphones and the Internet. The Internet is a table where we sit to gossip; a *suq* where we buy and sell; a shadowy corner for planning mischief; a library holding the entire world's information; a friend, a game, a matchmaker, a psychiatrist, an erotic dream, a babysitter, a teacher, a spy. It is what we need it to be. The best and worst and most ordinary of us, reflected—and perhaps distorted—in a silvery fog of bits.

We humans love to talk to one another. That's why we invented speech, writing, books, telephones, TV, travel, and now the Internet. These images tell the tale for the United States. The upper one maps an old technology: the flow of passengers on airplanes. The lower one maps the new: the flows of bits.

The various parts of our bodies also have to talk among themselves—that's how the brain, and spinal cord, and nerves evolved. How do our internal biological and external electromagnetic systems of communication compare? Evolution invented us, and then we became the multiple parents of the Internet. But postpartum, the Internet is evolving itself. It has *many* "brains"—ours and our computers'. In creating the world-wide web, we have not replicated ourselves on a planetary scale: we, and it, are entirely different. And so far, the web has not developed a "brain"—a central controller.

So far.

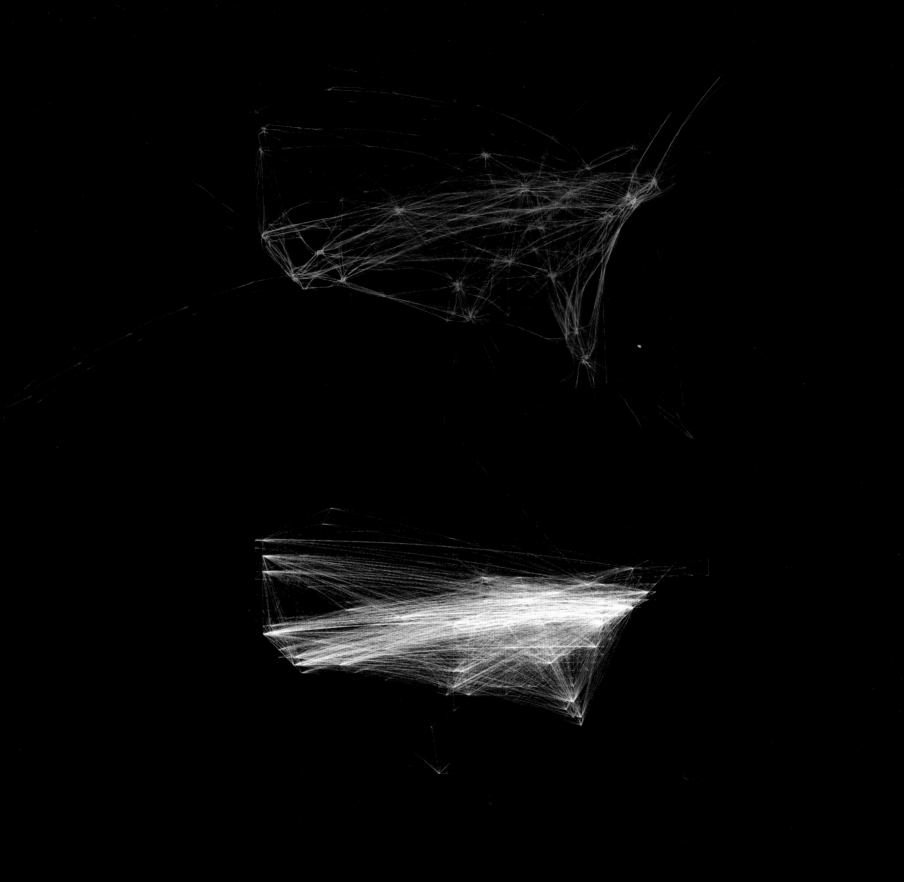

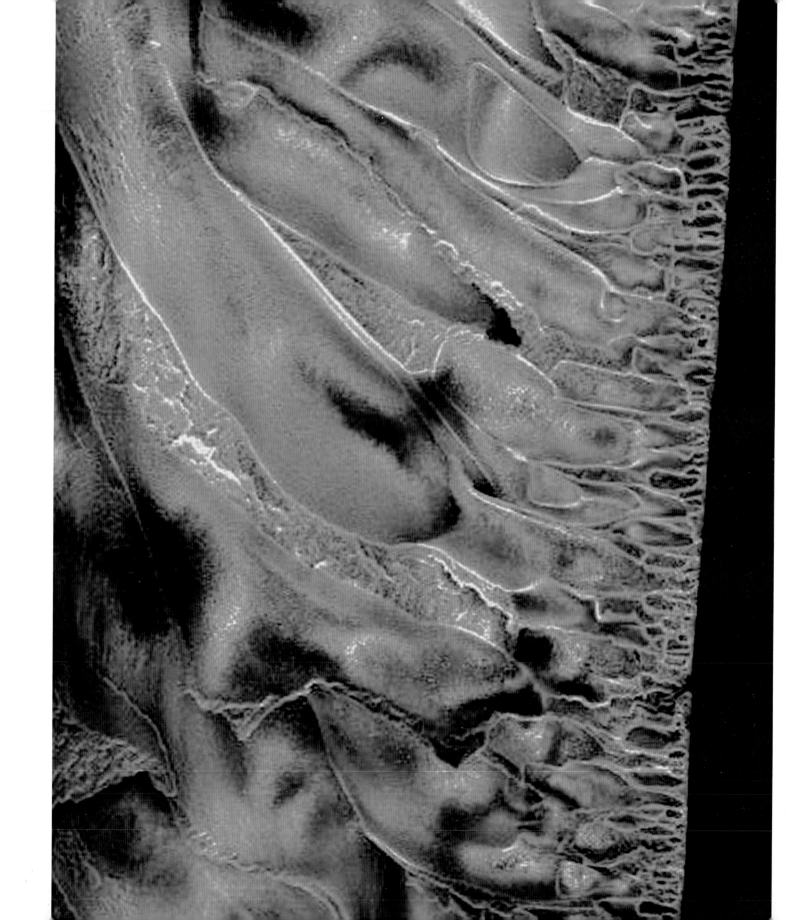

Reverse Osmosis Membrane

THE MIDDLE CLASS IS A SHIP that floats on clean water; water is the fluid foundation of societies. Without clean water, we share the intestinal organisms that are our fellow travelers in poverty: cholera, dysentery, schistosomiasis, giardia, cryptosporidium—all the old, old companions who have been very close to us (in fact, inside us) for millennia. Only with pure water can we build a prosperous, stable society.

If a fresh-water river or lake is available, it is relatively easy to get pure water. Filtration removes sludge, taste, and toxins. A touch of chlorine or ozone destroys the pathogens. Then drink! If the only available water is salty, a separate step is necessary to take out the salt: passage through a reverse osmosis membrane.

These membranes are functionally the nanoscale analogs of porch screens on a summer evening. Screens block flies and mosquitoes but not biting midges. Molecules of water and ions of sodium chloride (salt) are not so different in size but are very different in electrical charge: water has no charge; sodium and chloride ions are electrically charged. A reverse osmosis membrane bars the ions but allows the water molecules to slither through.

This image is the cross-section of an reverse osmosis membrane; its complex internal structure is a series of pores of sizes chosen to maximize its strength and durability, while simultaneously supporting a thin surface film that accomplishes the ultrafiltration. To force water through this membrane, and to separate pure from salty water, requires pressure—almost a thousand times the pressure of the atmosphere in which we live. Generating pressure requires energy and costs money, and can rupture a fragile membrane. There's no free lunch.

Nuclear Reactions

THE AMOUNT OF ENERGY that is available from chemistry—by combustion, from fuel cells and batteries—is limited by the characteristics of atoms and molecules. You can only get so much out of chemical reactions. We want *more*—more energy and cheaper energy—ideally, something for nothing. Is there nothing better?

Indeed there is: *nuclear* reactions. Rather than making new molecules by shuffling nuclei and electrons using chemistry, we can make certain nuclei shuffle protons and neutrons and form new *atoms*. The energies available from nuclear reactions are, perhaps, a million times greater than those available from chemical reactions. Unfortunately, the nuclear fuel must contain isotopes that fragment in a controllable way; uranium, plutonium, and thorium are the best, but all are rare and expensive.

And there are other problems. One is that uranium and plutonium make both power plants and nuclear weapons. A second is that most people don't want to live next to a nuclear power plant, very much don't want a nuclear waste site in the neighborhood, and most emphatically don't want to disappear in the transient sun of a nuclear explosion.

Nuclear power is, and will be, an essential contributor to the commercial production of energy. Beyond nuclear fission lies nuclear fusion—processes whose practical potential for producing power has been debated for decades—and beyond those, a range of even more energetic subatomic processes. This image shows—in a forest of other traces—evidence of the collision of pions (members of the zoo of exotic particles that fascinates high-energy physicists) with hydrogen atoms, written as strings of bubbles of hydrogen gas, in liquid hydrogen, at a temperature a few degrees above absolute zero.

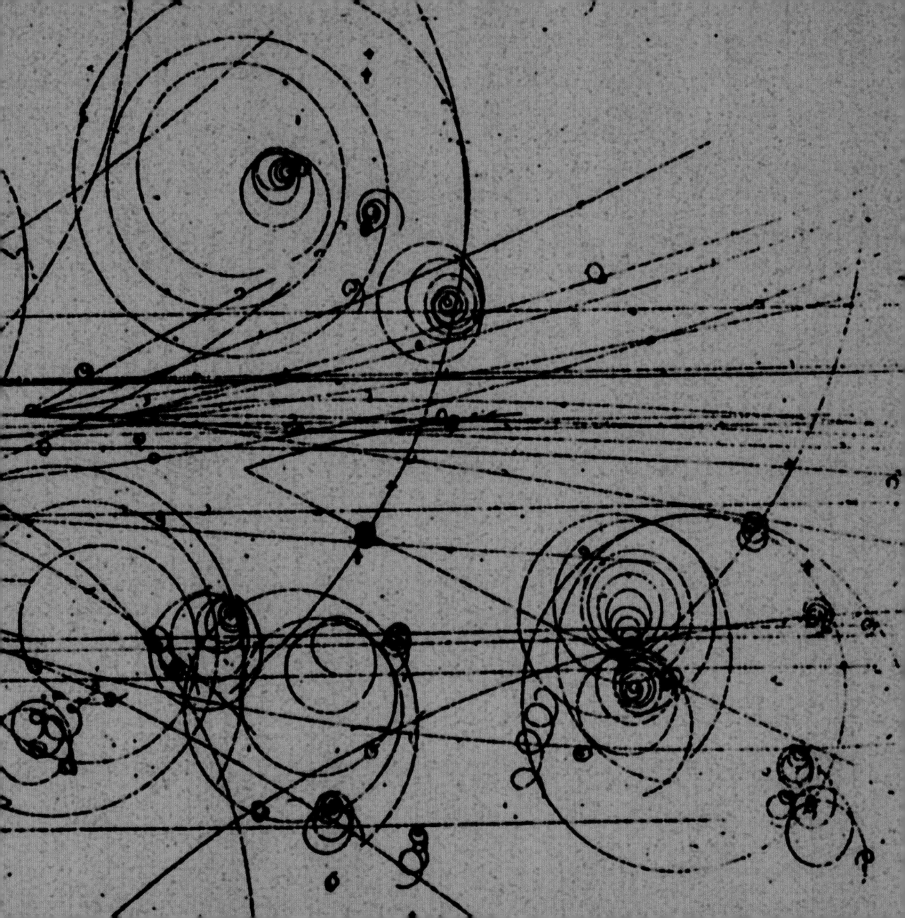

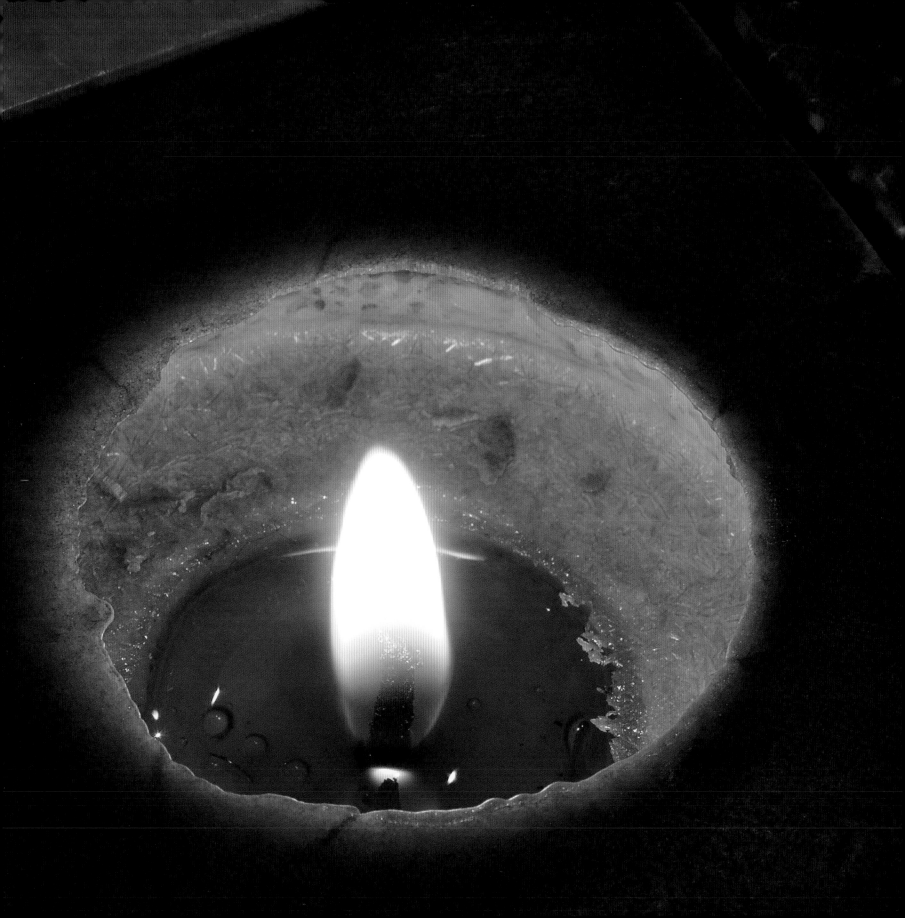

Flame

HEAT (to ward off the cold and cook food) and work (to help with the day's labor)—we have always needed both forms of energy. Most (85 percent) of the energy we humans now use comes from burning something—gasoline, methane, coal, wood. Burning seems straightforward, because flame is so familiar—but it is not.

Small structures occur everywhere along the chain of events that starts in the warmth of sunlight and ends in the heat of a flame. The capture of sunlight by algae and plants involves the complex biological apparatus of photosynthesis. The plants die; the very slow chemistry that later converts them into petroleum requires heat, pressure, and particles of clay. Transforming petroleum into gasoline involves industrial chemical processes carried out on an enormous scale, and catalyzed by nanoscale particles of platinum. A flame takes some of its color, and important parts of its chemistry, from small particles of incandescent carbon generated by incomplete combustion. "Smoke" is small particles of carbon remaining after combustion.

And the flame itself? The smallest flames share features in common with the largest: a burning candle tells the story as well as a coal-fired electrical power plant; only details are different in a coal fire and a diesel engine. Here, the heat from the flame melts the hydrocarbon candle wax; the liquid wax climbs up the wick; heat radiated from the flame vaporizes the wax; the vapor mixes with air; a complex series of chemical reactions in the hot region—the flame—convert wax and oxygen into carbon dioxide and water. At an intermediate point in the flame zone, small particles of unburned carbon—at a temperature of approximately 1,000 C—glow yellow. When combustion is incomplete, unburned carbon particles cool to smoke or soot.

Fuel Cell

MOST ENERGY IS GENERATED USING HEAT. Heat a gas, and it expands. Expanding gas can push a piston or spin a turbine.

Heat usually comes from burning something—coal, kerosene, natural gas, hydrogen. When a fuel—say, hydrogen (H_2, the simplest molecule; two protons and two electrons)—burns with oxygen (O_2), electrons move among atoms, the hydrogen and oxygen disintegrate and reform as water (H_2O), and the temperature soars. After hydrogen and oxygen have burned, very hot steam—water vapor—is all that remains.

There are few alternatives to hot, expanding gas as a way to get from fuel to electricity. One is a fuel cell. It also burns hydrogen and oxygen, but in a subtle, two-step way. A fuel cell is an elegant device that separates hydrogen from its electrons, uses these electrons to run a motor, and only then allows them to combine with oxygen and form water. The result is electrical power with little heat.

A fuel cell has two chambers, separated by a thin membrane. Hydrogen flows into one, air into the other. In the first chamber, on one side of the membrane, nanoscale particles of platinum separate electrons from hydrogen and send them into a wire that goes to an electrical motor. The protons that remain flow through the membrane into the second chamber. Here, on the other side of the membrane, similar nanoscale particles combine electrons leaving the motor, oxygen from air, and protons, and form water. The final result is the same as burning, but the procedure is different.

It sounds wonderful, and it can be. But like many wonderful things, fuel cells are expensive and complicated, and they sometimes drip. The present generation of fuel cells really only works well with hydrogen. And although there are many ways of generating hydrogen, they are all expensive, and the immediate benefits of hydrogen fuel cells—silent operation and clean air—may not justify their high costs.

This black film is the membrane, exposed for examination rather than buried in the interior of the cell. It is an astonishing piece of engineering. Protons (formed from hydrogen when its electrons are stripped away) flow though nanoscale pores in it; nothing (ideally; there is always some leakage) flows in the opposite direction other than water. The membrane's exquisite selectivity for protons is essential for the efficiency of the cell.

Solar Cell

WE LOVE THE IDEA OF something for nothing. We acknowledge, grumpily, that eventually our habit of picking over the graveyards of dead plants—coal deposits, oil fields—and burning what we find to generate energy will not keep pace with our appetites. Although we have enough coal to keep us warm for a long time, oil and gas are less certain, and anyway there's the nasty prospect that the carbon dioxide we produce will edge Earth's climate uncomfortably far toward that of Venus. Maybe we can tolerate crocodiles at the North Pole, but moving most of our civilization to avoid the rising sea? Bad idea. Alternatives to fossil fuels—nuclear power and wind—have both disadvantages and advantages. So why not solar power?

To generate electricity, photons from the sun—sunlight—must fall into the sea of electrons in a thin plate of silicon (actually, two face-to-face plates, with slightly different properties). Absorption of a photon sometimes kicks an electron a few hundred nanometers from its customary place, across the boundary between the plates. If everything works (and it usually doesn't), the itinerant electron may return home by going through an external wire, and turning a motor or generating hydrogen along the way. Sunlight is free; silicon solar cells operate for decades; they have no moving parts.

But there's always a catch. Sunlight is free, but *collecting* it is not. Silicon solar cells are expensive. And much of our life goes on when the sun is down: what about the batteries to provide electricity at night? Dust, leaves, snow, and bird droppings all dim the vision of solar cells.

Solar electricity is a good idea, but not a good enough idea to save us from ourselves. Either we have to find more energy elsewhere, or use less.

Plants and Photosynthesis

FROM SPACE, EARTH IS BLUE, white, green, and yellow. Blue for ocean, white for cloud, green for plants, and yellow for desert. Life depends on sunlight, water, and plants. We humans are almost unnoticeable.

Plants use sunlight, water, and carbon dioxide to make more plants. The machinery of this process—photosynthesis—is highly optimized: plants and their forebears have been perfecting it for several billion years. Plants were here long before we were, and we are here—eating them, and breathing the oxygen they exhale—as a sideshow in their photosynthetic circus.

The leaf is where the main events of this circus occur— "The Capture of the Photons! The Reduction of Carbon Dioxide!" The green color of leaves is the light they reject: they absorb mostly red. (The regions of red in these leaves show that there *are* other absorbers, with other colors.) The energy picked up from sunlight converts carbon dioxide to sugar (glucose) and incidentally generates oxygen. Plants build themselves out of glucose (as cellulose) and discard the oxygen. We need both: their glucose (as starch) is our daily bread, and their oxygen is the air we breathe. Plants make it; we mammals burn it.

Most of the energy we use—for heat, light, transportation, and the work of the world—also comes from burning the products of past photosynthesis, either directly (wood, peat) or after millennia of further transformation (coal, petroleum, natural gas). And now we expect plants to take up the carbon dioxide we produce by burning the remains of their ancestors, and reconvert it to something useful (or at least get it out of the way).

Most of our energy, all the oxygen we breathe, all the food we eat, the repair and replenishment of our atmosphere— that's a lot to ask of plants! We are less than grateful in return.

We glance, and turn away without noticing. We don't ever really see, and then we forget what we have seen. Water drips from faucets; candles burn; yeast makes bread rise; a tiny, living mouse—pursuing its tiny murine intentions—runs across a floor that was once a living tree; the sun consumes itself. We don't notice.

Look more closely, and everyday events bloom into a reality so transfixingly marvelous that you can't look away. Life becomes something we don't understand that happens in ordinary matter. Ordinary matter happens somehow when atoms get together. Atoms build themselves from electrons and nuclei, following rules that flummox intuition. Electrons and nuclei are strange avatars of yet stranger fish swimming in a darker sea.

But whatever it all is—this amazing assembly we so flippantly nickname "reality"—is all there is, and all we are.

FIVE NOT-SO-EASY PIECES

Notes from the Photographer

FROM THE BEGINNING, GEORGE WHITESIDES AND I understood that many of the images in *No Small Matter* would, of necessity, be metaphoric in order to communicate the invisible complexity of the micro and nano worlds. He started a list, which eventually expanded with various potential concepts coming from both of us. To suggest the nature of reality, George at first proposed a salami sandwich ("or pick your spread—peanut butter would be fine, but the filling has to show, and it has to be thin"). At that moment I panicked, thinking I was in deep trouble—I'm not good at salami. But over time we worked our ideas back and forth until we were both satisfied with the representation, scientifically and aesthetically. Our two perspectives became complementary. I presented him with a variety of photographic ideas that seemed to capture key concepts, and nudged him to think and write metaphorically. And his creative explanations of the science encouraged me not to be content with rounding up the usual suspects, or with just another pretty picture, but to aim for something more expressive.

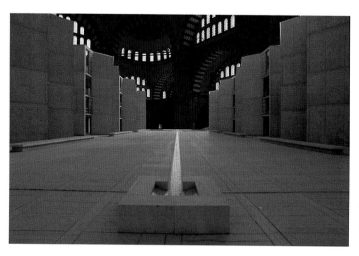

To ILLUSTRATE the counter-intuitiveness of the quantum world, I started with an image of a modified mosque and ended up with an image of a glass apple. How did this happen? In the first image, I was attempting to create a place that could never exist, by digitally combining what I thought were two incompatible buildings: the Salk Institute in La Jolla and the Hagia Sophia in Istanbul (both taken in my former life as an architectural photographer). But after some of my colleagues called the new "place" beautiful, I knew that the image wasn't suggesting the idea of uneasy contradiction that I had in mind. So I dumped it and moved on.

I had always loved a glass apple that my late husband received as a teaching award in surgery. It is both visually and tactilely pleasing, and seemed in some way to crystallize the notion of a quantum world where an apple isn't really an apple anymore. I photographed it from an overhead angle,

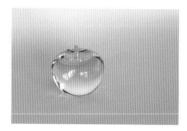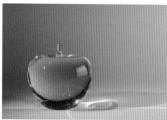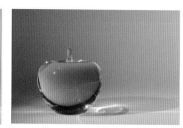

and when this was unsatisfactory, I tried a more frontal point of view—much better, although a distracting reflection from one of the light sources had to be digitally deleted.

The next challenge was how to suggest the idea of contradiction without screaming it at the reader. The solution, I decided, was in the shadow. The only thing I could find at the time to cast the shape of shadow I needed was a metal cube. I digitally pasted just the cube's shadow onto the apple photograph, and then stretched, pulled, and distorted it, trying to evoke a sense of counter-intuition. At one point I even cut a square hole in the shadow—a bit of overkill, I admit. After that, I decided that a simpler rectangle of shadow would work just fine.

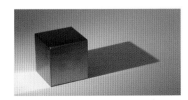

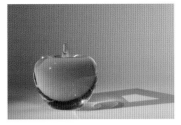

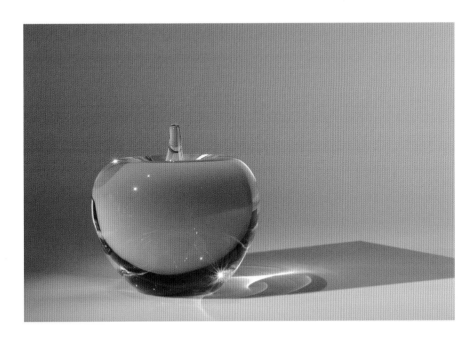

THIS WAS ONE of the first images I began to think about for this book. At first, my understanding of exactly what "binary" means was not clear. I thought I needed to show not 0's and 1's (nothing and something) but two states (this and that). So I started with a random pattern of colored glass pebbles, with no intended numerical meaning. In a second try, I used a more identifiable material, although few readers would guess that what they see on the left is salt and pepper.

George was concerned about the regularity of these images and suggested a pattern that could be translated into a binary equation. And to capture the idea of electron flow, he asked me to use a liquid that is present or not present in some sort of vessel. I began with water in one of my favorite sets of glasses and then tweaked the image in Photoshop. But when trusted friends told me the result was difficult to "read," I shifted the camera to an overview.

In what turned out to be my final shot, I filled a heavier glass with a wonderful Shiraz I was eager to try and photographed it, along with another unfilled glass. The result was quite satisfying (as was the glass of wine, which I emptied in celebration).

	Top row	0 0 1 1 0 0
+	Second row	0 1 0 1 1 0
=	Bottom row	1 0 0 0 1 0

Representing 12 + 22 = 34

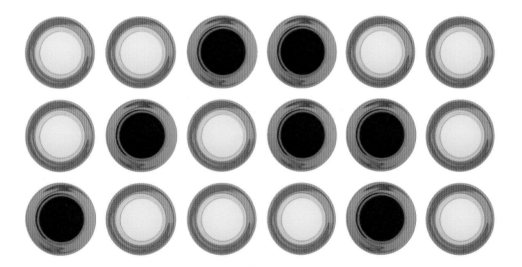

WHEN WE DECIDED to include an image of nanotubes, I approached the project photographically, as I usually do. But in my mind, the obvious image—a scanning electron micrograph—was not an option, because others have already done that, and much better than I probably could. The most productive course, I decided, would be to simulate nanotubes.

First I printed a black hexagonal pattern, representing a standard graphite lattice, on an 8x10 piece of transparent acetate. As I began to roll the acetate to make a tube, I had to decide how to connect the edges of the paper. Scientific sources informed me that there were indeed various possible configurations for carbon nanotubes, and that the ultimate configuration was significant in determining the electrical properties of the structure.

I decided (for aesthetic reasons) to adopt what's called the "zigzag" configuration. I secured the edges of the acetate with a couple of pieces of tape and placed the tube on my flatbed scanner.

The result was not terribly compelling. I then "inverted" the nanotube in Adobe Photoshop. Going further, I combined a few replications of the image to make multiple layers with varying degrees of transparency. Then, for what I thought would be the final composite, I adjusted the image using various filters and additional inversions.

The act of researching and creating this image taught me quite a lot about nanotube science. Whoever you are—a photographer manipulating a scientific image in today's virtual darkroom, a physicist sketching on a blackboard, a student reaching for a visual metaphor or graphing a function—understanding often comes through the act of representation.

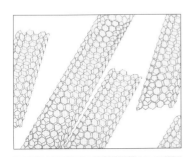

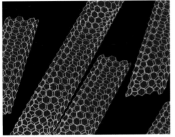

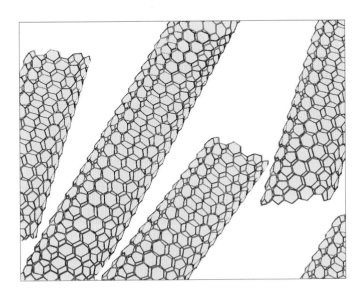

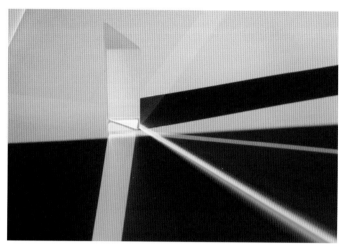

WHEN George and I began our list of possible images, he wrote to me that "most of quantum mechanics turns out to be represented in interference and diffraction." He went on to suggest a few ideas for that concept, including a standard-issue photograph of light dispersed within a prism. So using a glass prism I purchased on eBay (which came in a "handsome, black, soft flannel travel bag"), I tried a number of garden-variety photographs, some with a green laser pointer along with varied light from a window.

None were satisfying, even after cropping. For days, I walked around my house holding the prism and seeing some pretty spectacular spectra displayed on walls, ceilings, sofas, and all the rest. But again, nothing that I hadn't seen before in a textbook or blog jumped out at me.

Finally, on a cloudy day, I found what I was looking for. I propped the prism on a couple of leather boxes (which happened to have stitching) in front of venetian blinds drawn on one of the larger windows. The contrast between the

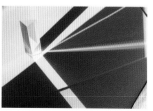
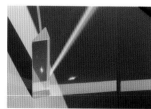
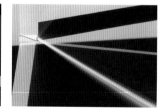
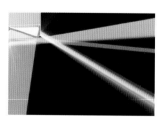

black and white pattern of the blinds and the brilliant colored lines inside the prism was dramatic and surprising.

For the book, I rotated the image 180 degrees. It just looked better.

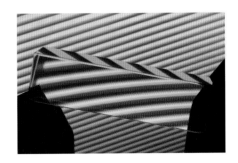

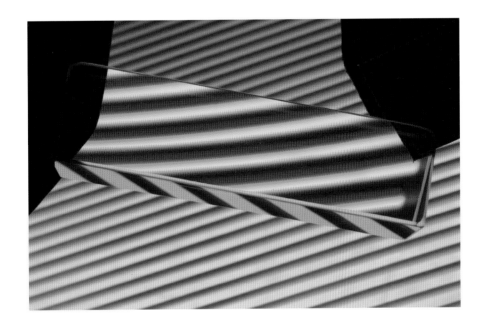

ALICE TING AND Peng Zou supplied me with two of their original images. The colored areas give highly detailed morphological information about the cell, as specific quantum dots attach to specific structures. When the dots are excited with ultraviolet light, they fluoresce and so we see where they attach.

In standard views of fluourescently labeled material, the colored areas are set against a black background. I thought it would be interesting, and perhaps informative, to see the information differently, as long as I maintained the integrity of the science. So I "inverted" the two images in Photoshop to get a white background. But because it was important to keep the original colors for the structures themselves, I changed the colors back to the red and green.

I then layered both of the images over a third image taken with standard microscopy, again supplied by the laboratory. The three-layered result shows the same information as the original separate images, with the addition of a sense of the whole.

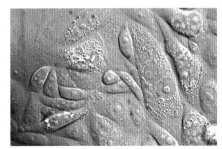

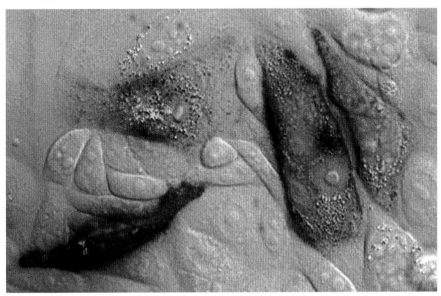

Further Reading

Dyson, Freeman. *Imagined Worlds*. Harvard University Press, 1997.

Feynman, Richard P., Anthony Hey, Tony Hey, and Robin W. Allen. *Feynman Lectures in Computation*. Westview Press, 2000.

Ford, Kenneth W. *The Quantum World: Quantum Physics for Everyone*. Harvard University Press, 2004.

Gribbin, John. *In Search of Schroedinger's Cat: Quantum Physics and Reality*. Bantam Books, 1984.

Hey, Tony, and Patrick Walters. *The New Quantum Universe*. Cambridge University Press, 2003.

Hillis, Danny. *The Pattern on the Stone: The Simple Ideas That Make Computers Work*. Science Masters, 1998.

Laughlin, Robert B. *A Different Universe: Reinventing Physics from the Bottom Down*. Harvard University Press, 2005.

Ozin, Geoff A., Andre C. Arsenault, and Ludovicho Cademartiri. *Nanochemistry: A Chemical Approach to Nanomaterials*. Springer-Verlag, 2008.

Ratner, Mark A., and Daniel Ratner. *Nanotechnology: A Gentle Introduction to the Next Big Idea*. Prentice Hall, 2002.

Von Baeyer, Hans Christian. *Information: The New Language of Science*. Harvard University Press, 2003.

———. *Taming the Atom: The Emergence of the Visible Microworld*. Dover Publications, 1992.

Acknowledgments

Nanoscience is a very broad subject, and we have been guided by many colleagues in thinking about it. Our principal indebtedness is, of course, to each other: this book reflects and refracts years of conversations and arguments about nanoscience, and science, and society, and how to explain one to the other. It is great fun (although not always effortless) to see in different colors of the spectrum, but to try to paint a picture together.

Beyond that debt, we have different networks of indebtedness to others, since the development of image and text follow separate paths, albeit one linked by common endpoints.

From GMW: Professor Mara Prentiss has been uniquely generous with her time and patience. I have taught a general education course on nanoscience and nanotechnology with Mara for years. Her discussions of the physics of small things have *always* brought up something new, unexpected, and interesting. Mara really understands how stuff works, including some of the parts of the universe I'm most interested in. Professor Howard Stone taught me most of what I know about microfluidics. The members of the DSRC (the Defense Science Research Council, a small group of scientists and engineers who advise DARPA—the Defense Advanced Projects Research Agency—on topics that include materials science and nanoscience) have given me at least a familiarity with almost everything interesting in condensed matter science.

Most academic scientists will say the same thing: their *best* teachers are often their students. Working with the graduate students and postdoctoral fellows in my research group at Harvard has been the most engaging thing about a career in science. The questions smart students ask—of themselves, and of me—have made it impossible to be anything other than excited by what science knows, and even more by what it doesn't know. Research in our group in nanoscience has benefitted enormously from collaborations with Ralph Nuzzo (on self-assembled monolayers, now affectionately and widely known as SAMs) and Mark Wrighton (on surface science and soft lithography). Colin Bain was especially important in starting the work on SAMs, and Abe Stroock and Rustem Ismagilov in taking up the subject of microfluidics. Without our long and productive collaboration with Don Ingber, we could never have worked effectively in cell biology. Collaboration with people both

smarter and more knowledgeable than you is one of the best things that can possibly happen in science.

A "final" draft of text (from the vantage of a writer) is usually the point at which the editors go to work to make something of it. The most important editor for the text in this book was my wife, Barbara Whitesides, whose detailed attentions enormously improved every aspect of the writing, from choice of metaphor to details of grammar; her skill in delicately rearranging words, and in pointing out ideas that I thought were good but that weren't, and in asking what on earth I was thinking of when I wrote *that*, have pulled large parts of the prose from something I could not bear reading to something that is tolerable. Susan Wallace Boehmer was the editor at Harvard University Press. She was essential to making the book clear, to refereeing differences of opinion, and to getting it finished. She was also important in wringing the excesses out of some of the metaphors, in restraining my instinctive improprieties, and in defending the prose. Becky Ward distilled simplicity out of complexity efficiently, gracefully, and with great skill.

One son, Ben Whitesides, with his lovely ear for prose, added a number of memorable phrases; the other, George T. Whitesides, conspired with Ben over many years to try to build a functional father of me. Being a father may seem unrelated to writing about science, but it is not. Among the many reasons that being a parent is the most wonderful of jobs is that it requires you to explain everything in the world in random order to curious children. If you can't first explain to yourself, you certainly can't explain to others. George and Ben, and Barbara, and Felice, Mara, and my students, have been my teachers, and I am—as a student should be—most grateful to them.

There are also a number of people—scientists and others—whose contributions to "nano" generally, and to my education in it, deserve specific thanks. Heine Rohrer and Gert Binnig invented the scanning probe microscope, and started it all; Cal Quate explained nanoscience to me in the beginning, and helped me to understand some of its opportunities and problems. Hank Smith taught me to think about nanolithography and nanoelectronics realistically. Mike Rocco was a tireless and effective advocate for the field in Washington in its infancy, and gave nanoscience a vital global push. Eric Drexler effectively generated public interest in nanotechnology well before it became a subject of general discussion. The Kavli Foundation's focused support for nanoscience has also helped it to grow.

From FCF: I am grateful to the Alfred P. Sloan Foundation for partial funding of my efforts for this book. I also want to thank the contributors of

some of the images in the book and for their generosity in permitting me to "tweak" a few, sometimes for clarity, sometimes just for fun. Their names appear in the visual index, and I encourage readers to take note.

Angela DePace, Rebecca Perry, and Rosalind Reid are friends and colleagues who have nudged—no, *pushed*—me to think about science and its visual expression in ways I would never have imagined. But more important, they have insisted that I exercise intellectual rigor, sometimes not-so-subtly asking how sure I was of the accuracy of my particular perspective. Rebecca Ward has done the same, and I am grateful to them all. Michael Halle has been an inspiration—always "getting" what I needed to understand and always leading me to a host of relevant new tracks.

Conversations with the many participants in the Image and Meaning workshops (IM), www.imageandmeaning.org, have confirmed the need for the science community to understand the potential of visual explanations to clarify and explain. The workshops proved to be an invaluable experience for me and the hundreds of participants who walked away knowing well that the challenges in visually representing science can have a profound effect on how one *thinks* about science. I am most grateful to Ruth Goodman for her outstanding accomplishment as project manager of the IM workshops, and I hope our efforts will continue.

The very best of the intellectual police have always been the students. They keep me honest. I am lucky to continue our dialogues through the NSF-Funded Picturing to Learn program, www.picturingtolearn.org, whose ongoing success is mostly attributable to the hard work of its project manager, Rebecca Rosenberg.

Special gratitude goes to Tim Jones, our remarkable designer at Harvard University Press. Tim somehow brilliantly created an intelligent balance between the images and prose. My thanks also to Eric Mulder, who finalized the many details.

And always, my deepest gratitude and love to my family for indulging my obsession with the visual expression of science: Matthew and Laura, Michael, and now my amazing new grandchild, Yosi. How lucky can one person be?

VISUAL INDEX

1. Santa Maria PAGE 12

This clover-leaf map is a woodcut made in 1581 by Heinrich Bünting in Magdeburg. Jerusalem is in the center, surrounded by Europe, Asia, and Africa. The ship *Santa Maria* is reversed to correspond with the text. The image is from the Norman B. Leventhal Map Center at the Boston Public Library.

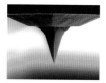

2. Feeling Is Seeing PAGE 15

This scanning electron microscope image of an atomic force microscope tip was generated with the help of Professor Christopher Love, MIT, and then digitally colored.

The field of pins in this image is a child's toy in which a rack of pins slides through a supporting sheet. Here, pieces of cardboard in contact with the back side of the array have pushed the pins forward, and caused them to replicate these shapes on the front side. The pins are about a millimeter in diameter.

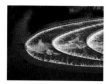

3. Quantum Cascades PAGE 18

This picture is of Pulteney Weir, on the River Avon, at Bath, in England. It was built in 1975 to reduce the risk of flooding.

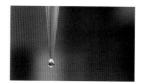

4. Water PAGE 21

The drop of water is suspended from a clear plastic pipette tip; only the sphere on the tip of the pipette is water. The length of the tip is approximately 3 centimeters.

5. Single Molecules PAGE 22

The original AFM image of individual molecules of a diblock copolymer was obtained by C. Tang, C. J. Hawker, et al. in the Materials Research Laboratory at the University of California at Santa Barbara. J. Pyun et al., "Synthesis and Direct Visualization of Block Copolymers Composed of Different Macromolecular Architectures," *Macromolecules* 38 (2005): 2674–2685.

6. Cracks PAGE 25

This image of a colony of lichen growing on weathered rock was taken at Naumkeag, Prospect Hill Road, Stockbridge, Massachusetts.

7. Nanotubes PAGE 26

In reality, single-walled carbon nanotubes can have diameters down to about 2 nanometers. Pages 158–159 explain how this photographic illustration was made.

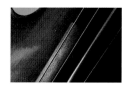

8. Vibrating Viola String PAGE 30

This "flopped" image shows an old viola with one string vibrating.

9. Prism and Diffraction PAGE 33

White light separates into colors on passage through this prism. An explanation of how the image was made can be found on pages 160–161.

10. Duality PAGE 34

The poem "You Fit into Me" is reproduced by permission of Margaret Atwood.

11. Interference PAGE 37

This experiment is a nanoscale recapitulation of the classic two-slit experiment demonstrating interference. The original experiment used light, while this one used electrons. Other experiments with slits of different geometries have actually demonstrated diffraction and interference from *molecules* passing through slits. Original images by S. Frabboni and G. C. Gazzadi, National Research Center on NanoStructures and BioSystems at Surfaces, Modena, Italy. S. Frabboni et al., "Nanofabrication and the Realization of Feynman's Two-Slit Experiment," *Applied Physics Letters*, 93 (2008): DOI 073108.

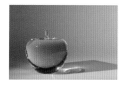

12. Quantum Apple PAGE 38

An explanation of how this image was made is found on pages 154–155.

13. Molecular Dominoes PAGE 41

This image shows an array of molecules of carbon monoxide on a surface, placed with an AFM tip. The initial structure is a three-input sorter. Pushing the molecules at the top of the array imitates a cascade that propagates down the array. The end result is a computation of the digital logic functions AND, OR, and MAJORITY. Image by Don Eigler, IBM Research Division. A. J. Heinrich et al., "Molecule Cascades," *Science* 298 (2002): 1381–1387.

14. The Cell in Silhouette PAGE 42

This experiment was designed to understand the directional control of extension of lamellipodia by constraining the shape of the cell. This constraint was accomplished by allowing the cell to attach to a pattern of "squares" formed using a type of molecule that allowed cellular attachment, on a surface otherwise covered with molecules that prevented attachment. Original fluorescent image by Cliff Brangwynne and Don Ingber, Children's Hospital, Boston. K. K. Parker et al., "Directional Control of Lamellipodia Extension by Constraining Cell Shape and Orienting Cell Tractional Forces," *FASEB Journal* 16 (2002): 1195–1204.

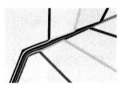

15. Laminar Flow PAGE 45

Liquids flowing in small channels (here, approximately 200 microns across) mix only by diffusion between the streams, not by formation of eddies or more complex processes. (Mixing does finally occur, by this diffusion, but the process is slow, and requires that the adjacent streams be thin.) In this image, each inlet stream feeds an aqueous solution of a colored dye into the system; the fluids exit (lower left) as a series of parallel, still unmixed streams. P. J. A. Kenis et al., "Microfabrication inside Capillaries Using Multiphase Laminar Flow Patterning," *Science* 285 (1999): 83-85.

16. The Wet Fantastic PAGE 46

This structure formed when two jets of water were allowed to collide at an angle of somewhat more than 90°. The image shows one jet clearly; the water is going into the plane of the paper. This jet obscures the second, which is only partly visible, with the water coming out of the plane. Image by John W. M. Bush, MIT. A. E. Hasha and J. W. M. Bush, "Fluid Fishbones: Gallery of Fluid Motion," *Physics of Fluids* 14 (2002): S8.

17. Fingers PAGE 49

The "posts" in this image are polymeric replicas, fabricated using nanomolding, of posts originally fabricated in silicon by electron beam lithography and directional etching. The structures formed when a suspension of polystyrene microspheres in water was placed on top of the array of posts and allowed to drain off and evaporate. Wetting of the posts, and capillarity, pulled these relatively flexible structures toward the spheres in the stage of evaporation in which the water film was only a few hundred nanometers thick. Image by Joanna Aizenberg, Harvard University. B. Pokroy et al., "Self-Organization of a Mesoscale Bristle into Ordered, Hierarchical Helical Assemblies," *Science* 323 (2009): 237–240.

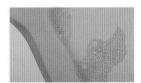

18. Soap Bubbles PAGE 53

These bubbles were formed in tap water, using household dishwashing detergent, and photographed on a green glass platter.

19. The Cell as Circus PAGE 54

The green filaments are images taken by fluorescence microscopy of green fluorescent protein (GFP) microtubules in a living bovine capillary endothelial cell. In this experiment, the gene for GFP (originally obtained from a jellyfish) was fused with the gene for the protein making up the microtubules, and the cell synthesized the fusion protein as it needed to form microfilaments. Image by Keiji Naruse and Don Ingber, Harvard Medical School and Children's Hospital, Boston.

20. Ribosome PAGE 57

This image is a computer construction of a complex between a part of the ribosome (the 70S component) and a tRNA. It suggests some of the enormous complexity of this structure. Image by Harry Noller. A. Korostelev et al., "Crystal Structure of a 70S Ribosome-tRNA Complex Reveals Functional Interactions and Rearrangements," *Cell* 126 (2006): 1065–1077.

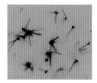

21. Bacterial Flagella PAGE 58

This is an image taken by high-resolution optical fluorescence microscopy. The body of a bacterium is approximately one micron in length. The original image, by Linda Turner and Howard Berg, was "inverted" in Adobe Photoshop. L. Turner et al., "Real-Time Imaging of Fluorescent Flagellar Filaments," *Journal of Bacteriology* 182 (2000): 2793–2801.

22. Life as a Jigsaw Puzzle PAGE 61

This image is of pieces of a jigsaw puzzle; it has been slightly manipulated to increase contrast.

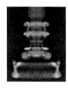

23. As the Wheel Turns PAGE 62

This image is a technical tour de force. It provides a cross-sectional image of the structure that anchors the bacterial flagellar motor into the cell wall and membrane, and allows the motor proteins to generate the torque that drives rotation of the flagella. The motor proteins, and the proteins that translocate protons, do not survive the process used to isolate these structures, and are not included in the image. The nature of these protein structures is known from x-ray crystallographic experiments. This structure was obtained by rotational averaging of 101 separate images, taken in multiple orientations, in order to increase signal-to-noise and to emphasize common features. Image by David DeRosier. D. Thomas et al., "Structures of Bacterial Flagellar Motors from Two FliF-FliG Gene Fusion Mutants," *Journal of Bacteriology* 183 (2001): 6404–6412.

24. Quantum Dots and the Cell PAGE 65

"Transfection" is a collective name for a variety of processes that introduce DNA (and sometimes other biomolecules) into a mammalian cell, by opening pores in its membrane and encouraging uptake of the DNA by various means. In these images, fluorescent proteins were used to label cells that had been successfully transfected, and combinations of antibodies and quantum dots used to recognize specific protein receptors generated by the transfected cells. Original images by P. Zou and A. Ting, MIT. An explanation of how the final image was made can be found on pages 162–163. M. Howarth et al., "Monovalent, Reduced-size Quantum Dots for Imaging Receptors on Living Cells," *Nature Methods* 5 (2008): 397–399.

25. Sequencing DNA PAGE 66

Forty years ago—in the dawn of DNA technology—sequencing was a technically difficult procedure involving analyses carried out by hand, and laborious development of sequence data by visual inspection of illuminated spots in thin gel films. Since then, the development of the technology for sequencing has been almost unbelievably rapid—substantially faster, by metrics of cost and size, than microelectronic technology. Now the entire process—from introduction of the sample to generation of the sequence—is entirely automated. For this image, DNA sequences were printed on two pieces of paper, which were then attached to a telephone book. The construction was then scanned on a flatbed scanner.

26. Molecular Recognition PAGE 69

This image is based on an X-ray crystal structure of the enzyme HMG-CoA reductase complexed with Simvastatin (a cholesterol-lowering drug). The crystal structure coordinates were obtained from the Protein Data Bank (http://www.rcsb.org/) using the PDB accession code 1HW9. The molecular model on which this image was based was produced by Demetri Moustakas, using the Chimera software package from the Computer Graphics Laboratory, University of California, San Francisco (supported by NIH P41 RR-01081). E. S. Istvan and J. Deisenhofer, "Structural Mechanism for Statin Inhibition of HMG-CoA Reductase," *Science* 292 (2001): 1160–1164.

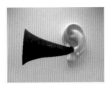

27. Harvesting Light PAGE 70

Art by John Baldessari, *Beethoven's Trumpet (With Ear)*, Opus 127, 2007. Resin, fiberglass, bronze, aluminum, and electronics. 73 x 72 x 105 in. / 185.4 x 182.8 x 266.7 cm. Image courtesy of Marian Goodman Gallery, New York.

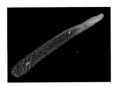

28. The Elegance of Simple Animals PAGE 73

The black and white scanning electron microscopic images in the collage were created by Joanna Aizenberg, Harvard University. The others were imaged on a flatbed scanner. All are of the mineral (silica nanospheres, in an organic matrix, but with compositions that vary with the position in the organism) skeleton of a sponge (Venus's Flower Basket, *Euplectella* sp.). The cells of the original, living organism have been removed. J. Aizenberg et al., "Skeleton of *Euplectella* sp.: Structural Hierarchy from the Nanoscale to the Macroscale," *Science* 299 (2005): 275–278.

29. Antibodies PAGE 76

This transmission electron microscope image is of a mixture of monomeric IgGs (anti-DNP) and aggregates (mostly dimers and trimers). The aggregates formed when a solution of the IgGs were presented with divalent haptens, with the two ends capable of interacting with binding sites on two IgGs, but too short to bridge the binding sites on a single IgG. The original image by Jerry Yang first appeared in black and white, and was colorized for this book in Adobe Photoshop. J. Yang et al., "Self-Assembled Aggregates of IgGs as Templates for the Growth of Clusters of Gold Nanoparticles," *Angewandte Chemie International Edition* 43 (2004): 1555–1558.

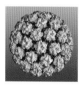

30. Virus PAGE 79

This image is a computer reconstruction of the capsid (the highly structured aggregate of proteins that forms the outer shell of a virus) of a human papillomavirus particle. This type of virus is of substantial medical interest, since papilloma viruses are associated with disorders ranging from cervical cancer to warts. Image by Yorgo Modis and Steve Harrison, Yale University. Y. Modis et al., "Atomic Model of the Papillomavirus Capsid," *EMBO Journal* 21 (2002): 4754–4762.

31. Writing with Light PAGE 83

The magnifying glass on the left produces these light forms, which are the basis for a number of studies in physics, and included in the fascinating field of caustics.

32. Eleanor Rigby PAGE 84

The Beatles' vinyl album *Revolver* yielded this image using a microscope with Nomarski Differential Contrast.

33. Abacus PAGE 87

There are several different systems used in abaci. This one is still often used in China. Its use is described in a number of sources, including http://www.ee.ryerson.ca/~elf/abacus/intro.html.

34. Counting on Two Fingers PAGE 88

This image illustrates binary addition. It's a very easy system to learn, although easier for computers to use than for people. Wikipedia has a clear explanation for those who might be interested in actually trying it: (http://en.wikipedia.org/wiki/Binary_numeral_system). The arrangement of glasses illustrates this addition:

$$001100$$
$$+010110$$
$$=100010$$

See pages 156–157 for an explanation of how the image was made.

35. Babbage's Computing Engine PAGE 91

Image courtesy of the Science and Society Picture Library, London, England.

36. Computers as Waterworks PAGE 92

These pipes and valves are part of a water system in Cambridge, Massachusetts. The image was simplified by digitally deleting parts of a distracting background.

37. Microreactor PAGE 95

This microreactor was developed for the continuous synthesis of nanocrystals. Working in a microfluidic system (the channels are about 400 microns across) brings a greater measure of control over the system than can be achieved with macroscopic systems. B. K. H. Yen, "Microfluidic Reactors for the Synthesis of Nanocrystals," Ph.D. dissertation, MIT, Department of Chemistry, 2007. The journal *Lab on a Chip* describes many applications of this kind of device.

38. Templating PAGE 97

The black and white image of the block copolymer, self-organized by epitaxial self-assembly, was generated by scanning electron microscopy. The period of the structures in the image is 48 nanometers. Image by Paul Nealey, University of Wisconsin. The larger image of chairs, set up in lines for the parents of graduating students, was taken at MIT. S. O. Kim et al., "Epitaxial Self-Assembly of Block Copolymers on Lithographically Defined Nanopatterned Substrates," *Nature* 424 (2003): 411–414.

39. Catalyst Particles PAGE 101

This digitally-colored transmission electron micrograph shows particles of composition "Pt3Co," whose purpose is to provide enhanced catalytic activity for electrochemical reduction of O2 in various applications, such as fuel cells. The original image was in black and white, obtained at Oak Ridge National Laboratory by Y. Shao-Horn (MIT), P. J. Ferreira (University of Texas, Austin), and L. F. Allard (ORNL). P. J. Ferreira and L. F. Allard, "Enhanced Activity for Oxygen Reduction Reaction on 'Pt3Co' Nanoparticles: Direct Evidence of Percolated and Sandwich-Segregation Structures," *Journal of the American Chemical Society* 130 (2008): 13818-13819.

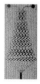

40. Christmas-Tree Mixer PAGE 102

One of the major differences between fluid flows in small channels ("microfluidics") and in large channels is the absence of turbulent mixing. This device (nicknamed a "Christmas-tree mixer") makes it possible to mix two fluids flowing side by side in very thin (50 micron) streams using diffusion. That mixing allows the formation of gradients using appropriate microchannel designs. These gradient mixers are used in a range of experiments in cell biology. Image from the Whitesides laboratory, Harvard University. N. L. Jeon et al., "Generation of Solution and Surface Gradients Using Microfluidic Systems," *Langmuir* 16 (2000): 8311-8316.

41. Self-Assembly PAGE 105

One-centimeter glass balls were poured onto two glass dishes with slightly curved surfaces, and tapped lightly. They "crystallized" immediately.

42. Synthetic Nose PAGE 106

Single images from a video supplied by Todd Dickinson and David Walt, Tufts University, were digitally "seamed" together to simulate a film-strip suggesting lapsing time. The video is an optical readout of a sensor reading organic vapors. T. A. Dickinson et al., "A Chemical-Detecting System Based on a Cross-Reactive Optical Sensor Array," *Nature* 382 (1996): 697–700.

43. Millipede PAGE 109

The millipede was originally developed by IBM. One possible application was as a reader for information. This particular application may not be commercialized, but devices using multiple atomic force microscope or scanning tunneling microscope tips are being developed for a wide range of applications, from printing biochemical sensors to reading information. Image courtesy of IBM, Zurich.

44. e-paper and The Book PAGE 110

This e-paper is the material that provides the page for current e-books. This sample was supplied by E-Ink Corporation, Cambridge, Massachusetts.

45. Lateral-Flow Assay as Crystal Ball
PAGE 113

The positive pregnancy test imaged here was obtained using a commercial product that uses lateral flow immunoassay.

46. Testing Drugs in Cells PAGE 114

This image shows a mammalian cell cultured in a Petri dish, taken using fluorescence microscopy. This picture illustrates particularly clearly the points at which the cell attaches to the surface of the dish, and some features of its internal structure. Image by Julia Sero and Don Ingber, Harvard Medical School and Children's Hospital, Boston.

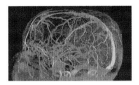

47. Cooling the Fevered Brain PAGE 117

Injection of magnetic nanoparticles (dextran-coated magnetite) into the blood stream enhances the contrast in magnetic resonance imaging between flowing blood and tissue, based on the ability of these particles to shorten the relaxation time of water molecules. The original black and white image was provided by Advanced Magnetics, Inc., Cambridge, Massachusetts, which also makes the magnetic particles. Colors were added in Adobe Photoshop.

48. Phantoms PAGE 120

This photograph is of the Tanner Fountain at Harvard University, during summer (when it sprays a cooling mist over the rocks—to the delight of children). The image was originally taken for a book about modern landscape architecture.

49. Privacy and the Nest PAGE 123

This detail of a hornet's nest (*Vespa crabro*) was photographed in the Department of Entomology, Harvard University Museum of Comparative Zoology.

50. Soot and Health PAGE 124

The combined smoke from three lighted cigarettes gave this image.

51. Robots PAGE 127

The small fly is part of a program by Rob Wood at Harvard to build microvehicles capable of autonomous flight without human intervention or control. The fly was supplied by Ben Finio, Katie Byl, and Jessica Shang of the Harvard Microrobotics Laboratory. R. J. Wood, "The First Takeoff of a Biologically Inspired At-Scale Robotic Insect," *IEEE Transactions in Robotics* 24 (2008): 341–347. The music box mechanism is designed to play "Jingle Bells."

52. Fog PAGE 130

Photographed at John Deere Headquarters, Moline, Illinois, for a book about modern landscape architecture.

53. In Sickness and in Health PAGE 133

This *Bacillus subtilis* sample, growing on a gel medium in a Petri dish, was prepared by Hera Vlamakis in the laboratory of Roberto Kolter at the Harvard Medical School. The colony is about 2 centimeters across, and approximately a millimeter thick.

54. The Internet PAGE 136

Both images are computer representations of large sets of data. The upper visualization shows flight patterns of commercial aircraft: "Flight Patterns - Aaron Koblin 2009." The lower shows bit flows on the internet, and was prepared by Chris Harrison, Carnegie Mellon University.

55. Reverse Osmosis Membrane PAGE 139

Reverse osmosis membranes are designed and fabricated to have an elaborate, asymmetrical structure by precipitation of polymer from a solution at an interface. The precipitation develops the network of pores that provide—on the front face—the capability for discriminating water from ions, and in the rest of the membrane the mechanical strength and channel system needed for the membrane to withstand the conditions in which it operates. This electron microscope image was originally in black and white, and was colorized using Adobe Photoshop. Original black and white image by A. Asatekin, MIT. A. Asatekin et al., "Anti-fouling Ultrafiltration Membranes Containing Polyacrylonitrile-*graft*-poly(ethylene oxide) Comb Copolymer Additives," *Journal of Membrane Science* 298 (2007): 136–146.

56. Nuclear Reactions PAGE 140

Trails of charged atomic particles moving through liquid hydrogen in a bubble chamber; tiny bubbles mark the paths energetic particles have taken. This colored image shows tracks produced by collisions of pions with hydrogen atoms. The curling shape reflects movement of charged particles (largely electrons) in an imposed magnetic field. The curvatures help to characterize the mass and charge of these particles. Original black and white image from CERN.

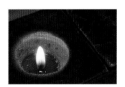

57. Flame PAGE 143

This image is just what it seems: a candle (four inches wide) that would decorate a dinner table.

58. Fuel Cell PAGE 144

This membrane is a multilayer construction, designed in part to resist permeation by methanol, in a type of fuel cell that uses methanol (rather than hydrogen) as fuel. The piece of membrane shown here is several centimeters across, and approximately a millimeter thick. It comprises a number of different layers, each with different functions. Membrane supplied by A. Argun, MIT. A. Argun et al., "Highly Conductive, Methanol Resistant Polyelectrolyte Multilayers," *Advanced Materials* 20 (2008): 1539–1543.

59. Solar Cell PAGE 147

This image is of a microscopic area of the top side of a silicon-wafer-based photovoltaic solar cell with a low-reflectivity surface consisting of a hexagonal array of pits. The surface appears blue-violet due to an antireflective coating of silicon nitride. Light that is absorbed in the wafer creates charge that moves to the surface to be collected by the narrow (<40 micron) silver conductor lines shown in the image as a gold-colored strip. Sample wafer supplied by 1366 Technologies, Lexington, Massachusetts.

60. Plants and Photosynthesis PAGE 148

Photograph taken at the Bloedel Reserve, Bainbridge Island, Washington, in a garden originally designed by Rich Haag.